DAVID BAILEY'S TROUBLE AND STRIFE

DAVID BAILEY'S

with 81 illustrations in duotone

TROUBLE AND STRIFE

Photographs by David Bailey

Preface by J H Lartigue

Introduction by Brian Clarke

Thames and Hudson

For Marie Helvin-Bailey

DAVID BAILEY'S ACKNOWLEDGMENTS

I would like to thank the following for directly or indirectly helping
me to make this collection possible: Michael Spry for the
photographic prints and Ian Stirling of Downtown Darkrooms;
British, French and Italian *Vogue*; Yves St Laurent; *Ritz*
newspaper; Hazel Gates; Aurelio D'Angelo; Cezar de Paulo; and
Barry Taylor of Olympus Optical (UK) Ltd.

PUBLISHERS' ACKNOWLEDGMENTS

The publishers would like to thank Barry Taylor and Olympus
Cameras, whose support has helped with the production of this book.

Introduction

David Bailey has had only two love affairs in his life, one with photography and one with beautiful women. It is difficult to say which of these two affairs has taken up most of his energy, but I have noticed that – while I have often seen him with only one beautiful woman – I have never seen him with less than two cameras.

He is without question the most famous living photographer, and yet curiously he remains the most underestimated.

For the last five years at least, we in England have been exposed to the best of so-called 'art photography' from Continental Europe and the USA. We have seen major exhibitions of Kertész, Brassaï, Cartier-Bresson and Gibson and our vocabulary of photographic imagery has been extended immensely. Five years ago 'art photographers' in this country were almost to a man opposed to the use of colour because it offended the barriers of graphic purity, coming dangerously close, they thought, to commercial photography. The major threat was that colour might effectively destroy the introverted, contemplative and *unreal* image of the world as presented by a

monochromatic photographer and replace it with an extraordinary and beguiling view of reality. Colour photography to them represented one of the fallen angels of consumer demagogy. Yet, five years later, at least one in three 'creative' photographers works in colour, and now black and white photography, though it still provides some of the most considerable images, is regarded with comparable disdain.

The same muddle-headed self-indulgence preoccupies most art photographers in their arbitrary dismissal of fashion photography and, apart from a few outstanding exceptions, art photographers still fail to realize the immense potential of this genre.

Bailey realized it over twenty years ago; and since his first assignment for British *Vogue* in 1959 he has spearheaded a highly original and investigative course through trend after trend and fashion after fashion without, for any discernible length of time, losing his own intensely personal signature or integrity. His output has been as vast as his interests. Probably the most prolific of all fashion photographers, Bailey is also a portraitist of immense stature. His seminal series of *Pin-ups* and studies for *Goodbye Baby and Amen* were the foundations for an entirely new kind of interpretative and uncomprising portraiture that rank him historically alongside Steichen, Sander, Avedon and Penn.

Over the past few years it has been necessary for me to have my portrait taken by some of the world's most accomplished photographers. They have all been different except for one thing: I have been able to control the result of every picture. In this Bailey was the single exception. He controls and controls totally the sitting and the result. No photographer has impressed me so much by the power of his visual intelligence. He is always precise, definite and determined in instructions to his models and this inevitably results in his pictures, whether they are fashion or portraits, being economical, concise and to the point and with a statuesque and arrogant dignity that is unrivalled in the history of photography.

In 1965 he photographed, amongst others, the Kray brothers, Michael Caine, Mick Jagger and Jean Shrimpton. His recent portraits for *Ritz* newspaper show that there has been no loss of intensity of vision since then – only a consolidation and maturing of ideas.

Trouble and Strife is neither a book of fashion photographs nor of portraits. It is a series of 'intimate snapshots' of Bailey's wife Marie Helvin, Bailey's own private record as 'a ransom against time'. It isn't in any way a definitive chronicle of Bailey's photographic achievements, though for those who, like me, are fascinated by any aspect of the visual language of an articulate artist, these pictures represent an interesting armature of ideas,

some stronger and more resolved than others, that make up a composite view of Marie and a provocative antinomic view of Bailey. The book in microcosm emphasizes the difference between Bailey's two main areas of activity, fashion and portraiture, the one elegant and glamorous and the other, stark, lonely and menacing. It is when these two elements touch and briefly overlap that Bailey is at his strongest.

He has 'invented' during his career several women whose images are now part of the corporate psyche, but with Marie Helvin he has created some of his most enduringly elegant pictures. The pictures in this book present another view of Marie, sometimes erotic, sometimes cadaverous, but always beautiful.

At 42, Bailey has a position in the history of the medium that is assured and unassailable; more than ever before he rides on the crest of a wave, but he did – after all – make the wave himself. It is his unfathomable energy and sense of wonder that keeps Bailey at the top; he never relaxes, never rests on his laurels. Indeed, I think it would take a life peerage, a Nobel Prize and the Légion d'Honneur to make Bailey relax, and then only until after dinner.

Brian Clarke
LONDON May 1980

Paris 28 Octobre 1979

Avoir pour amour une femme aussi belle, jolie, charmante et troublante que Marie, quelle inspiration pour un artiste.

Avoir pour amour un artiste aussi doué et magnifique photographe que David Bailey, quelle chance pour une adorable femme.

Etre le livre contenant le résultat de cette merveilleuse rencontre, quelle certitude pour lui d'être superbe.

J. H. LARTICUE

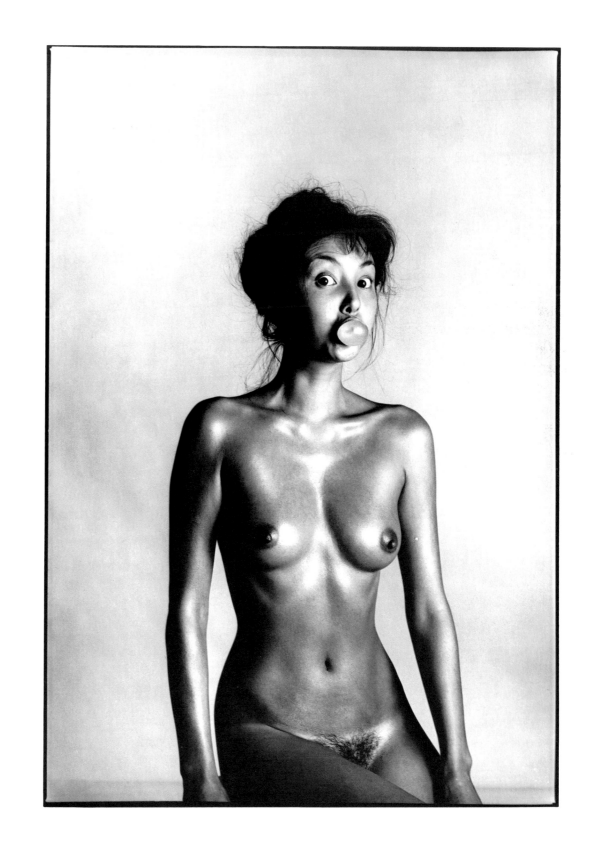

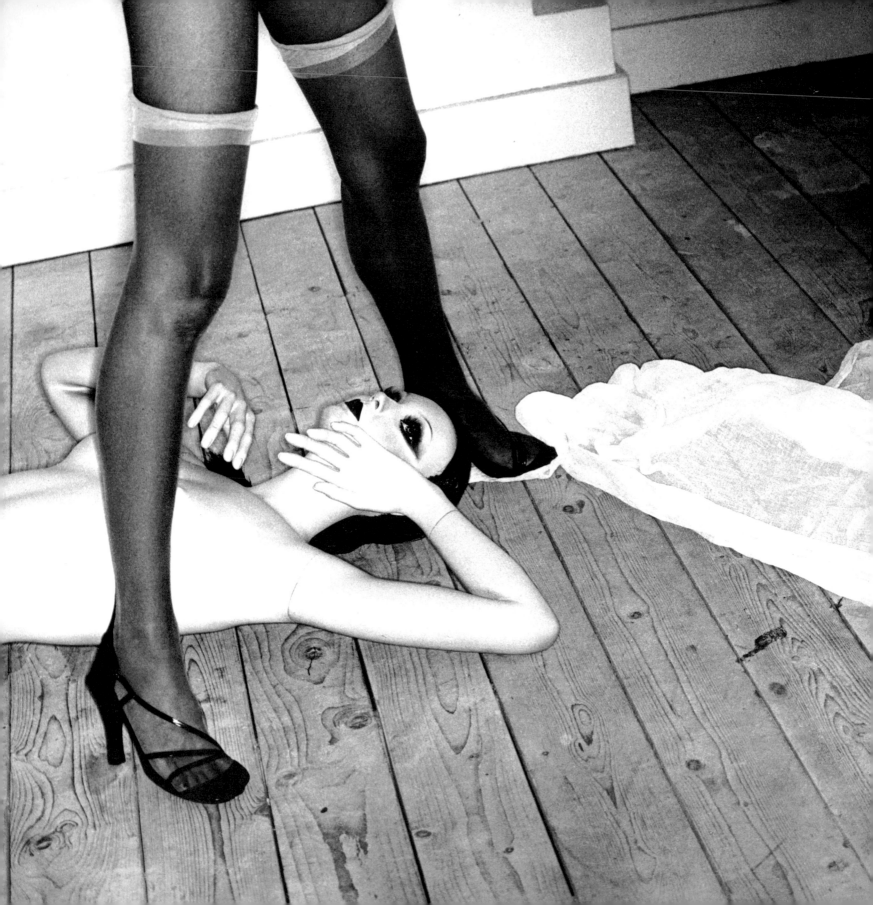

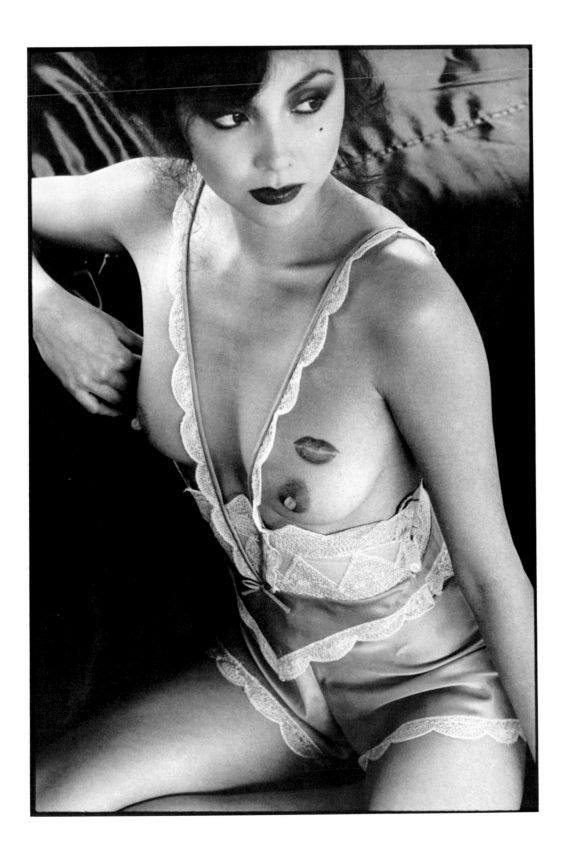

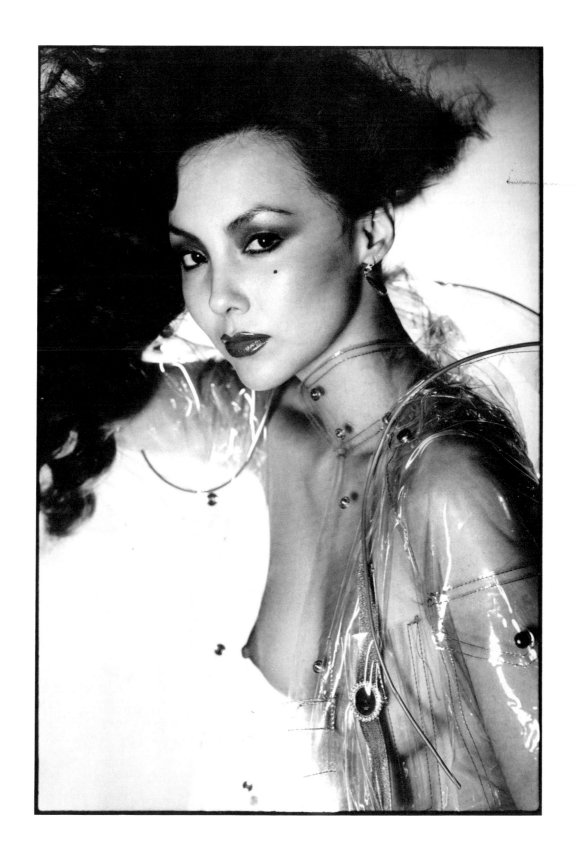

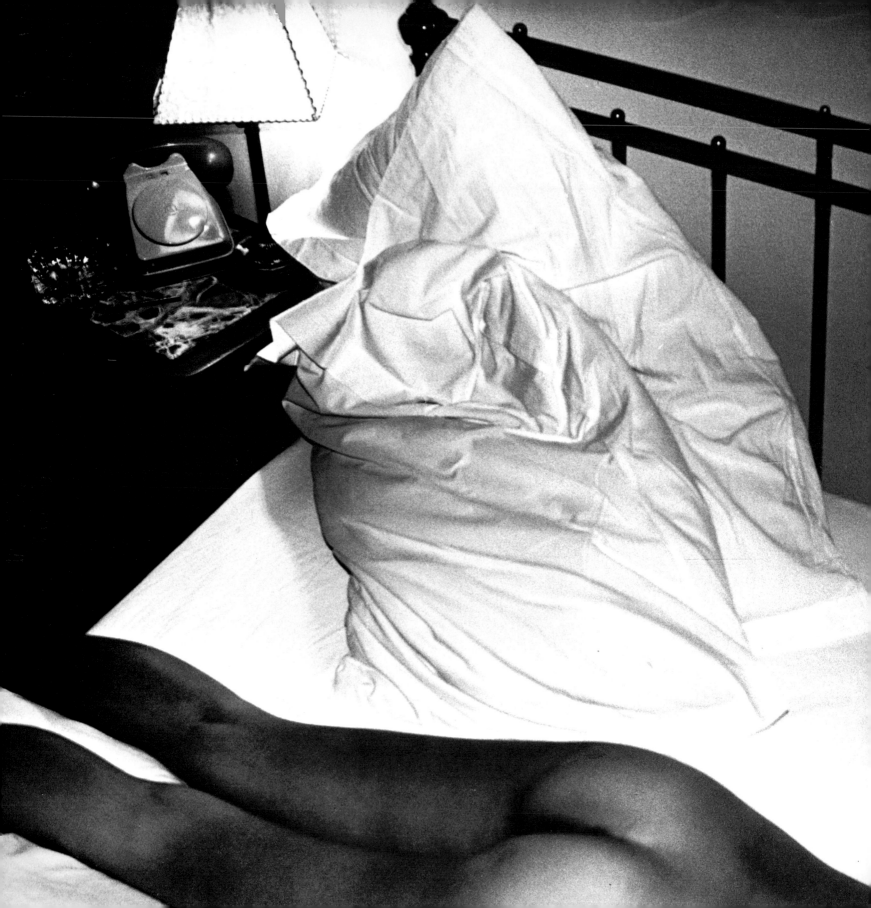

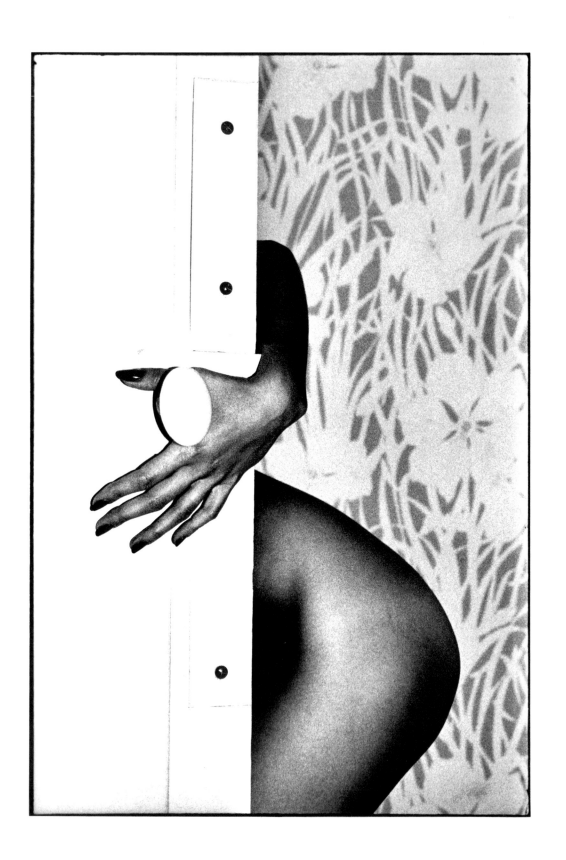

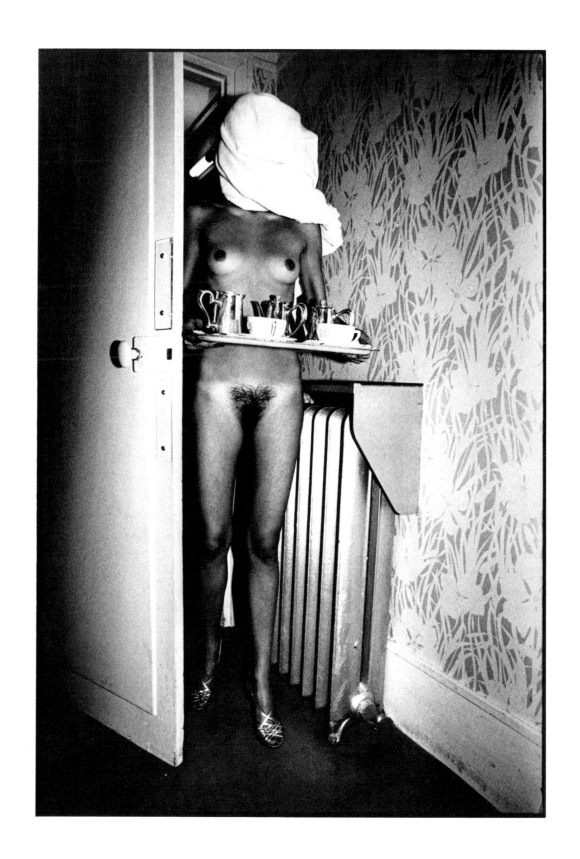

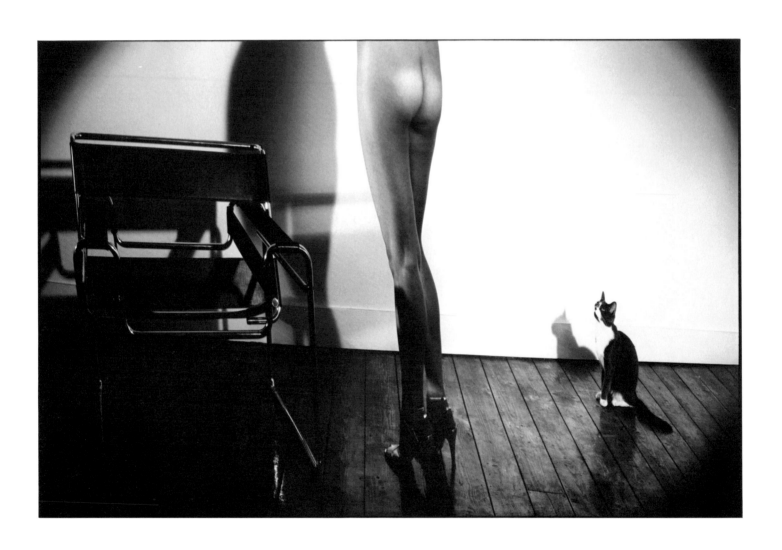

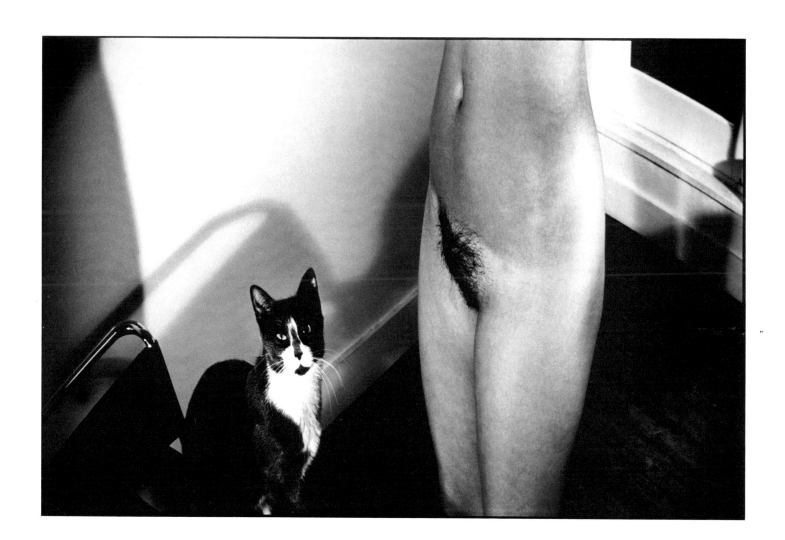

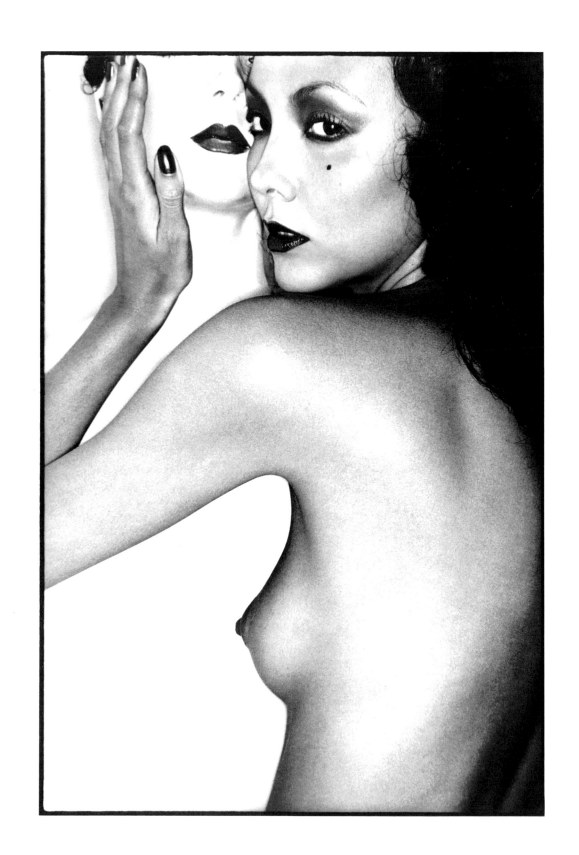

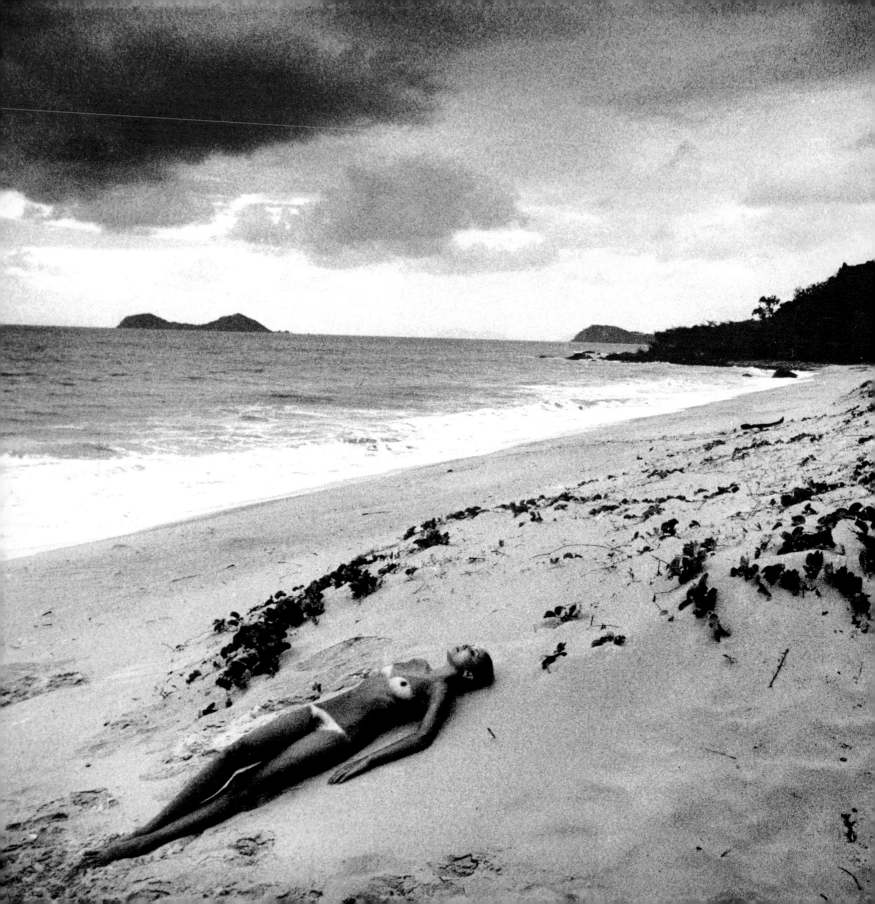

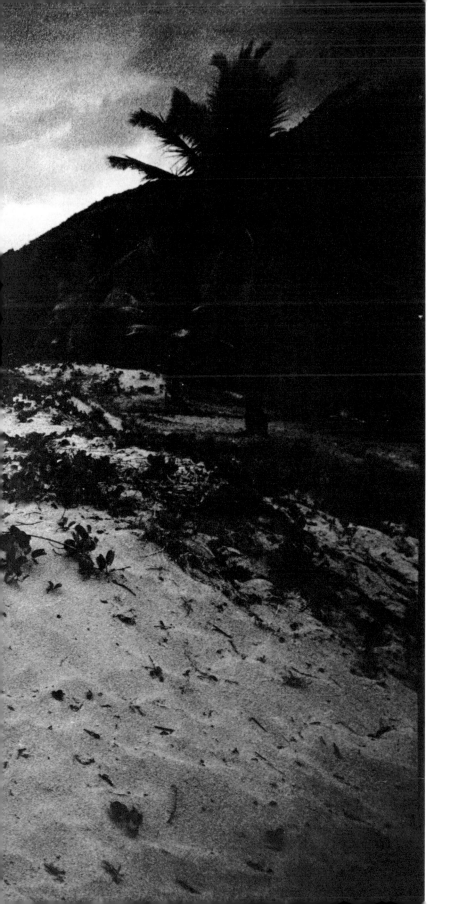

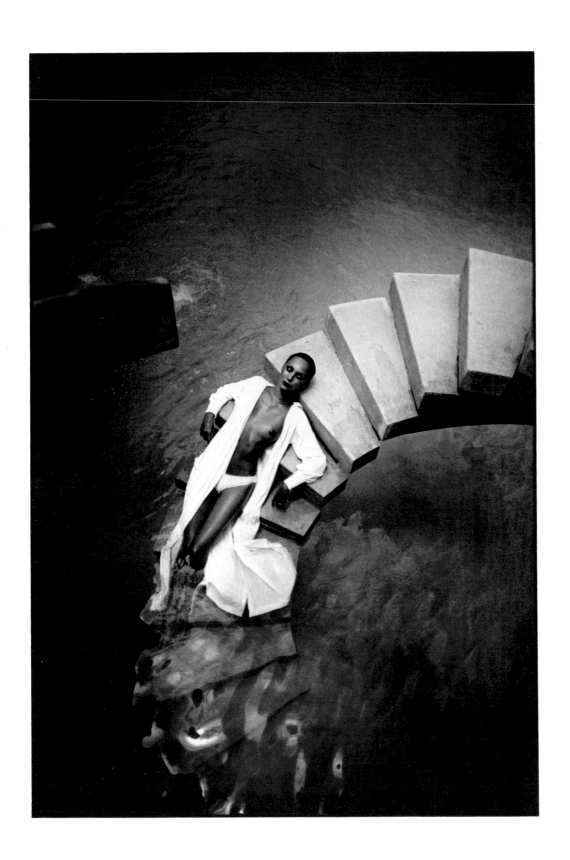

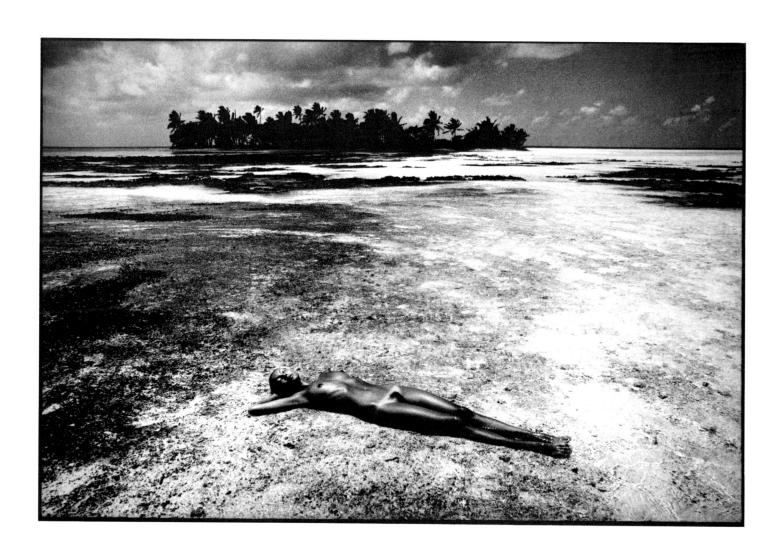

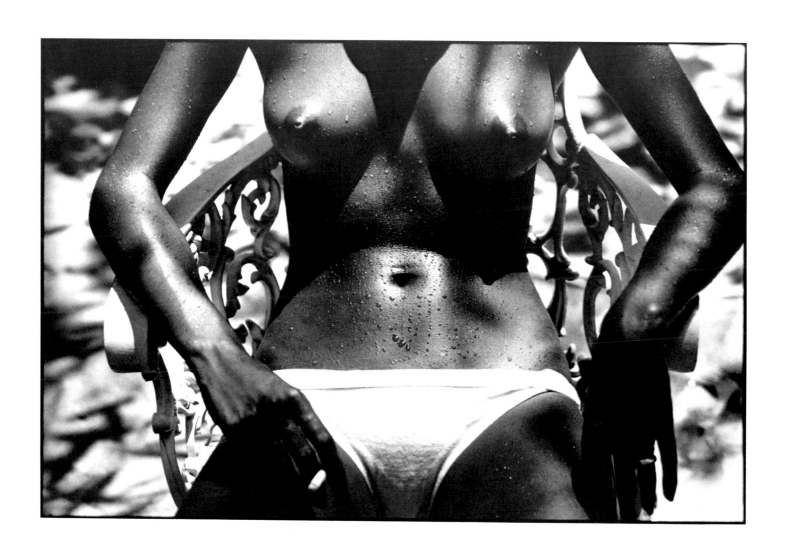

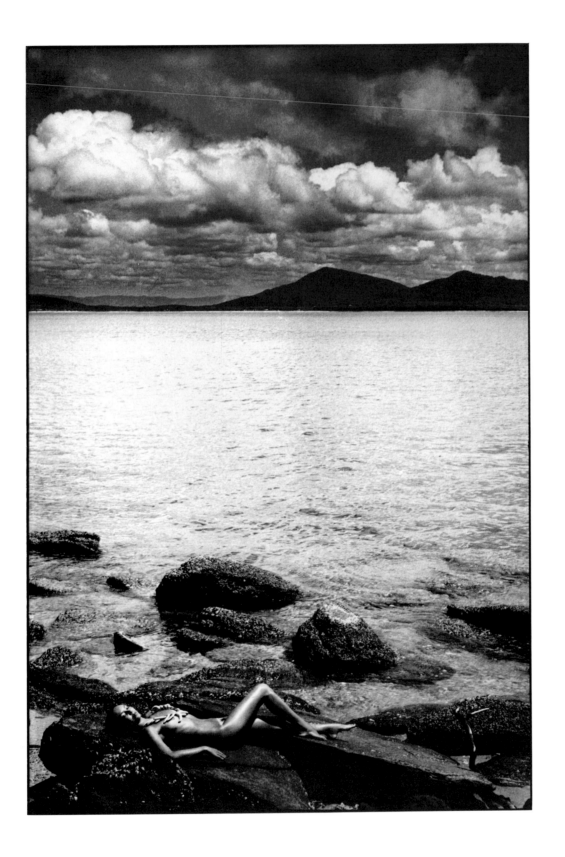

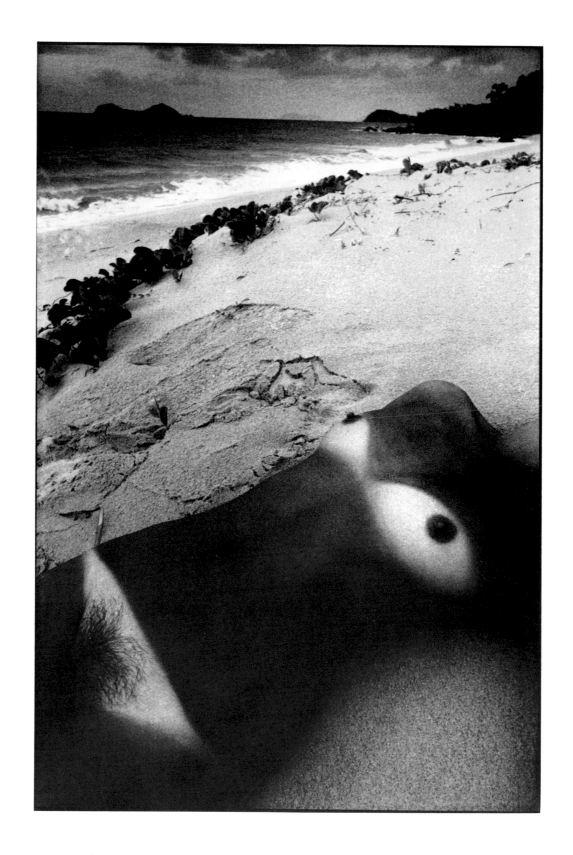

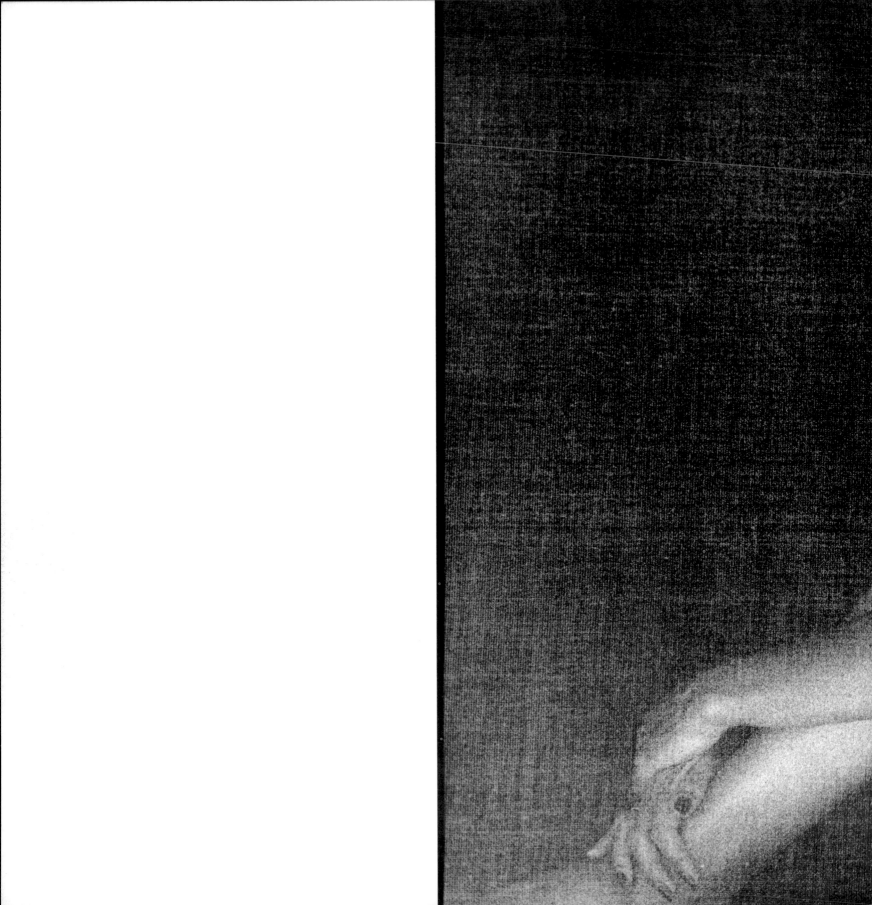

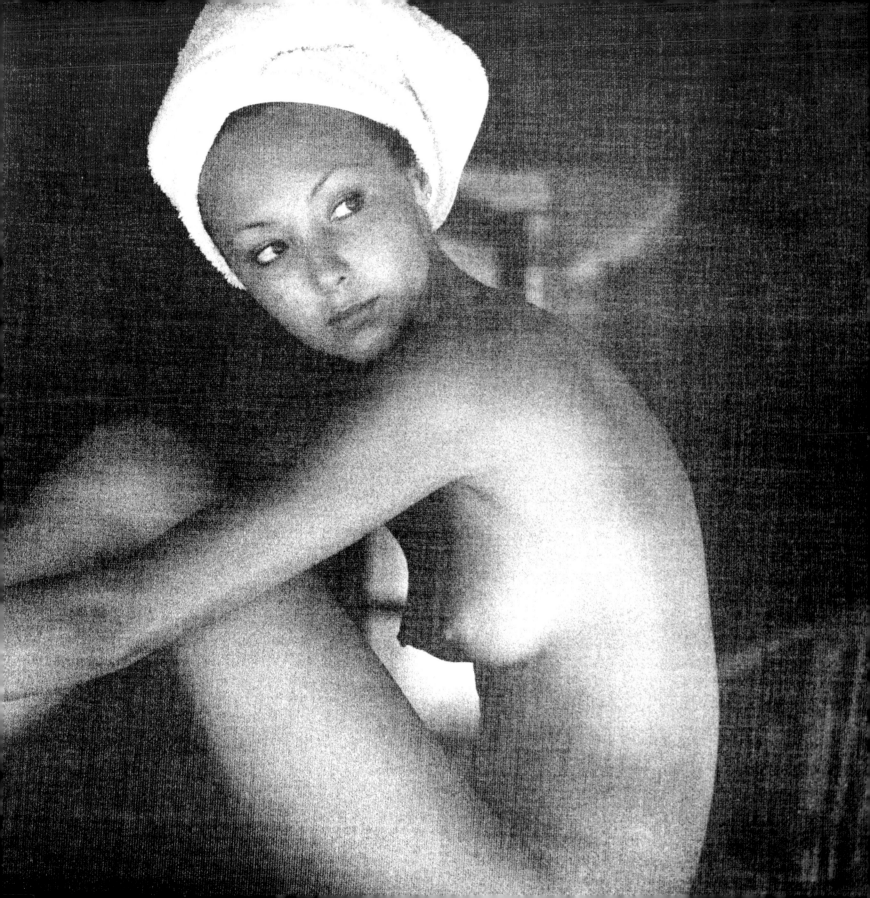

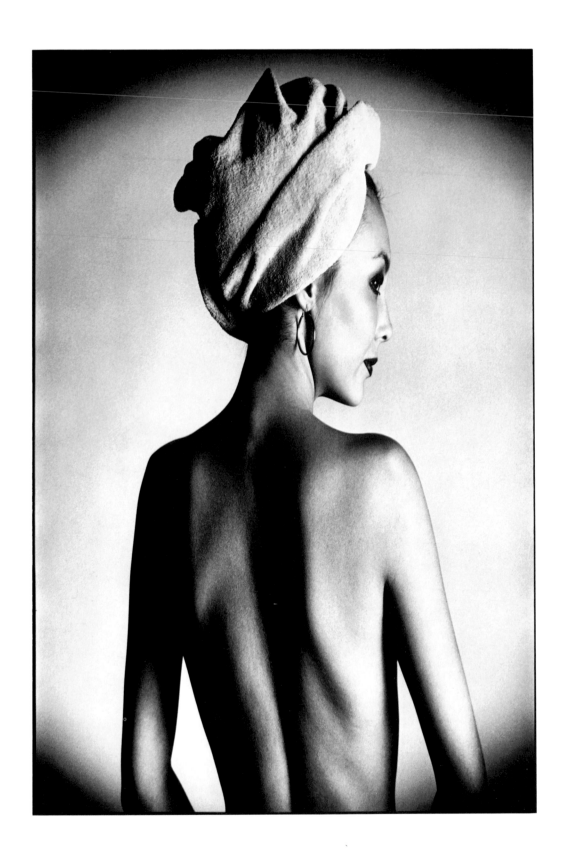

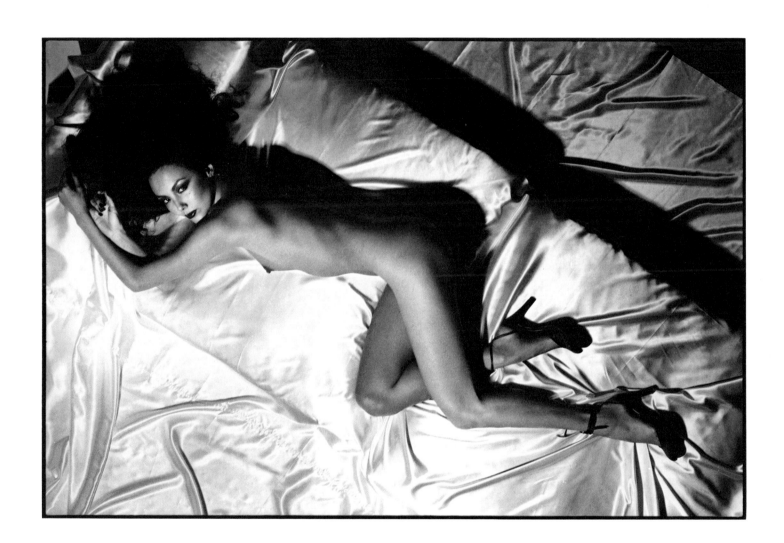

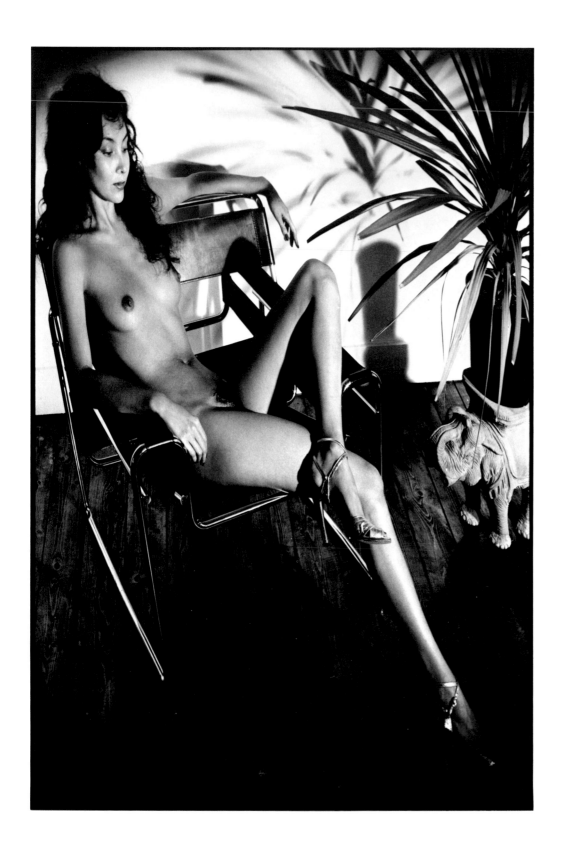

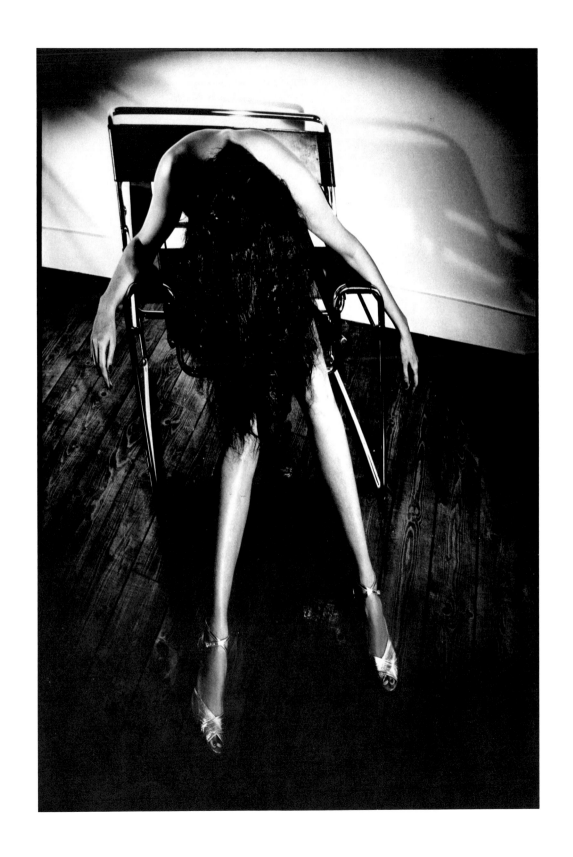

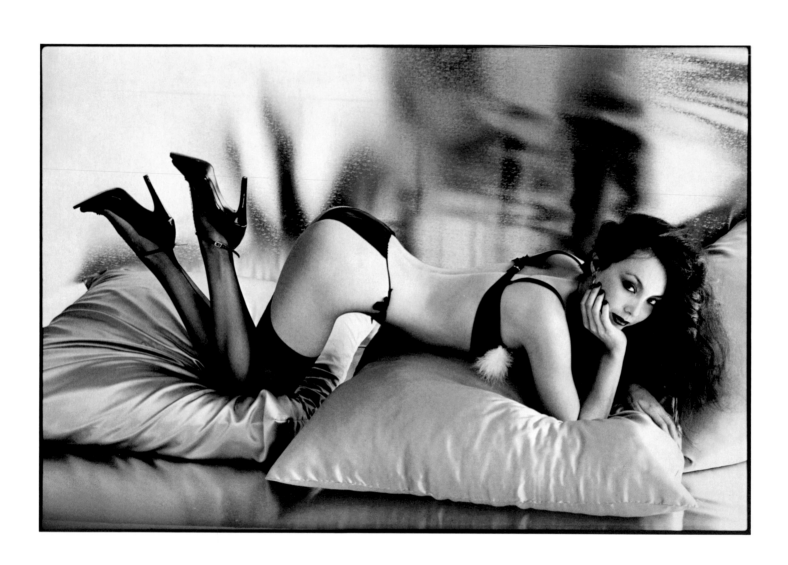

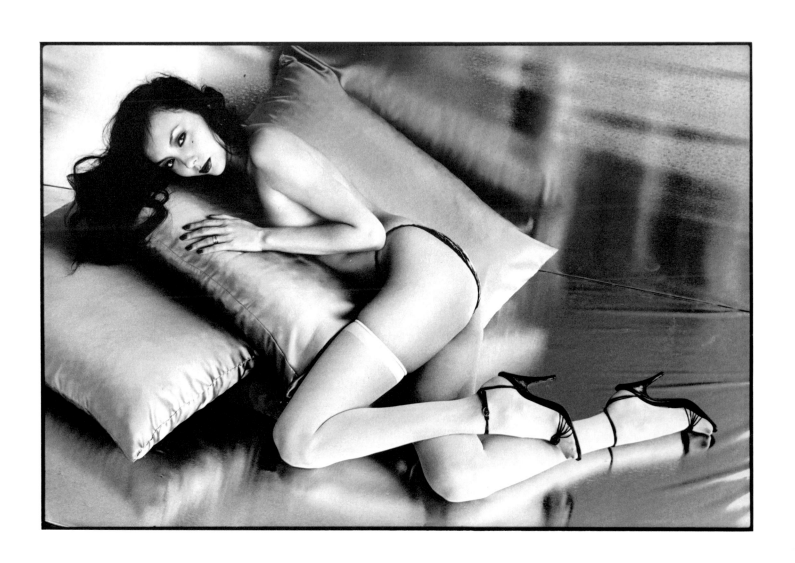

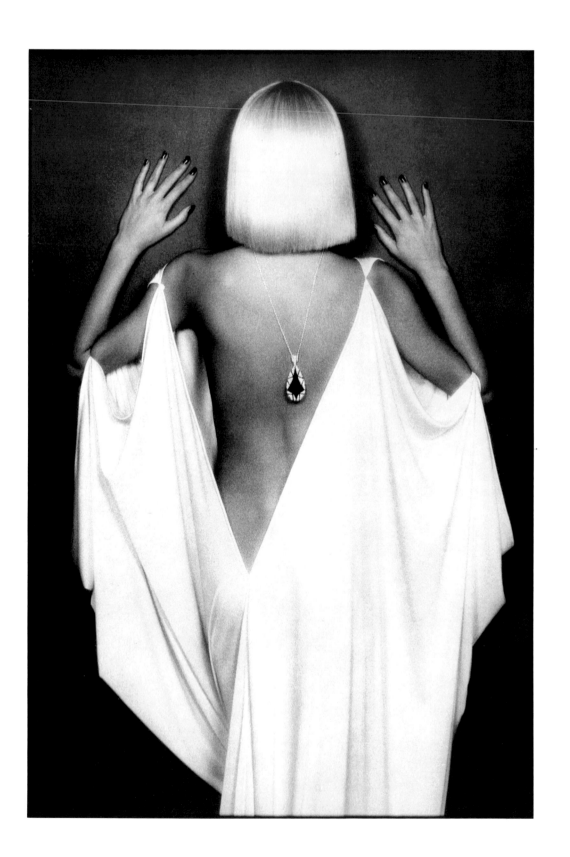

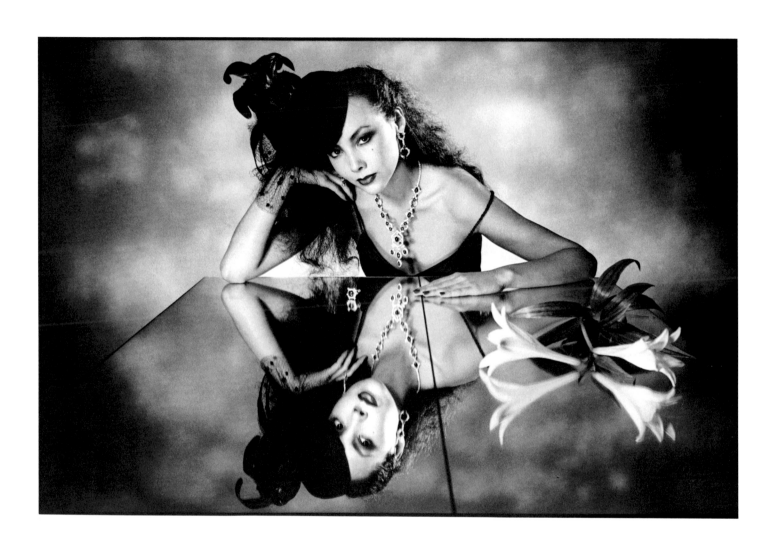

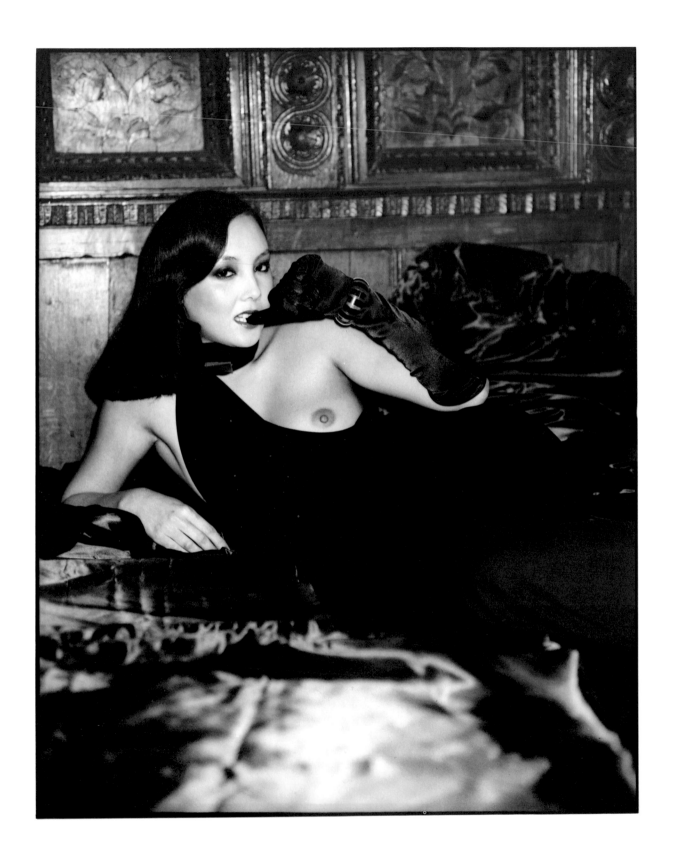

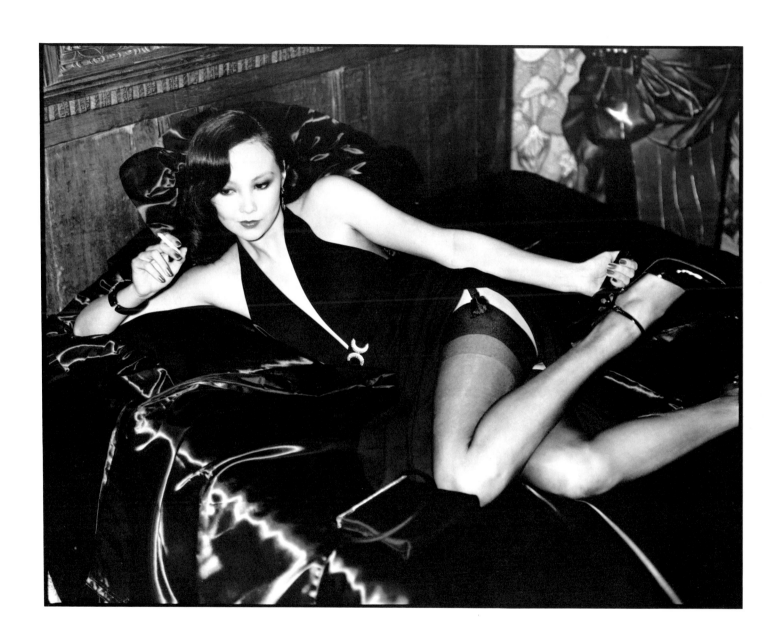

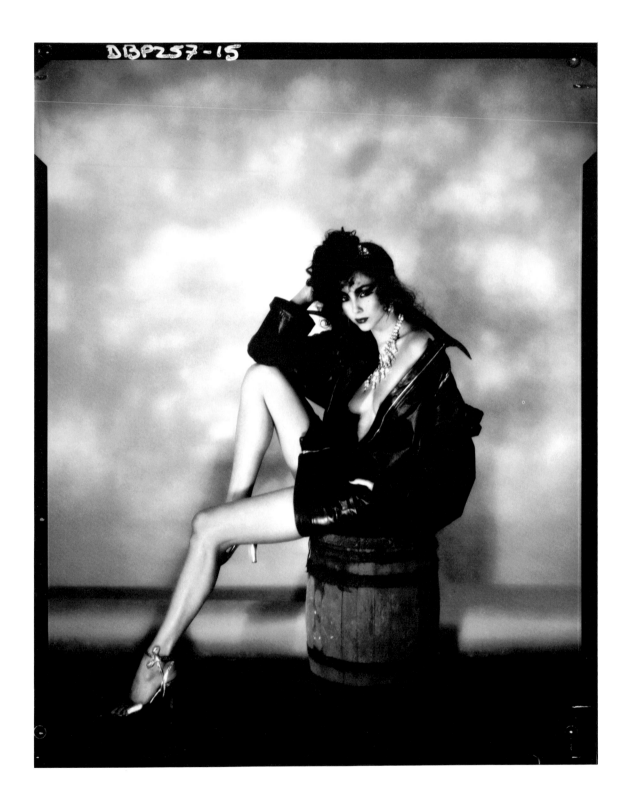

DBP257-15

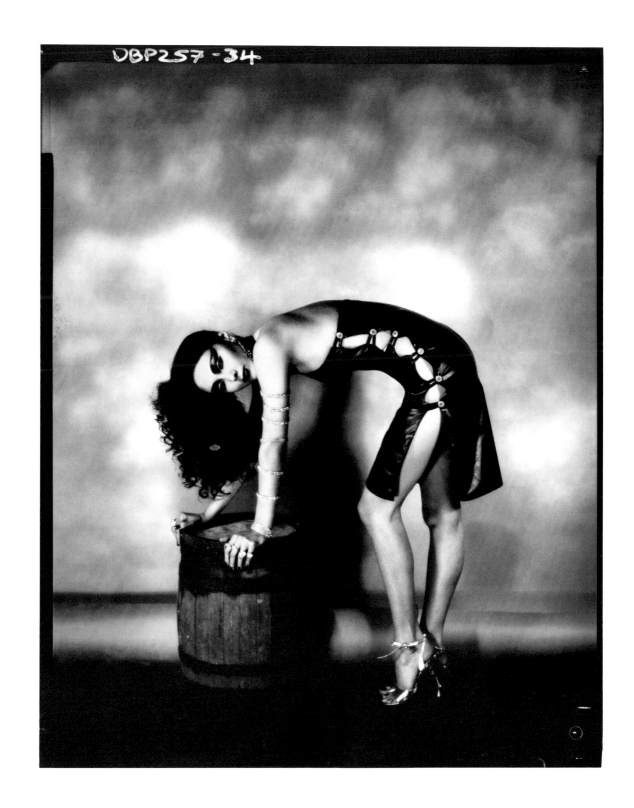

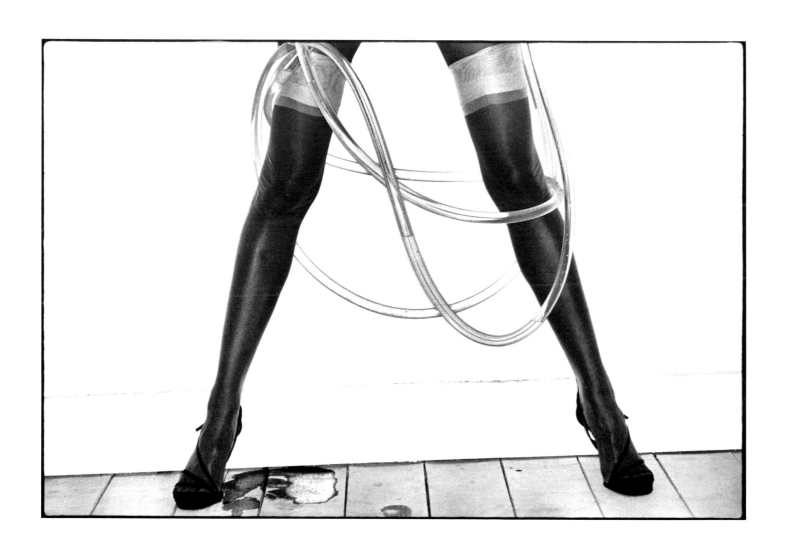

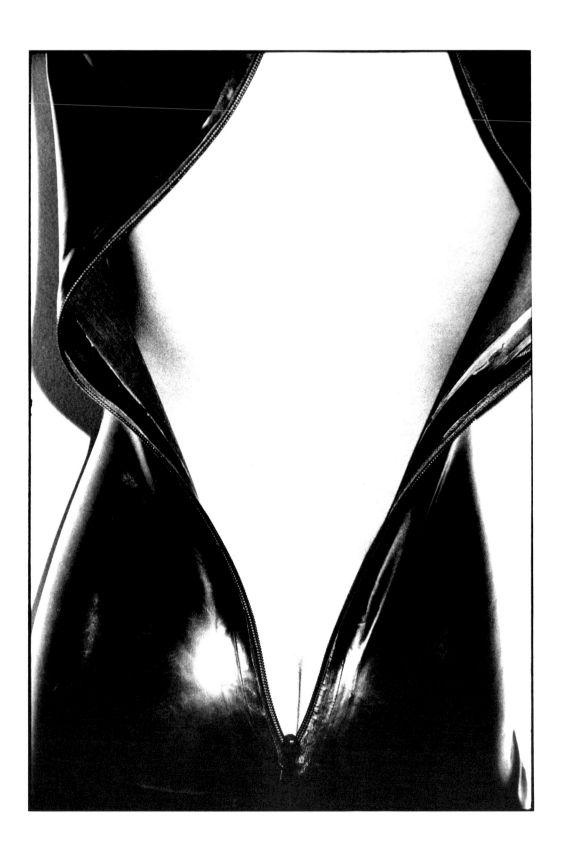

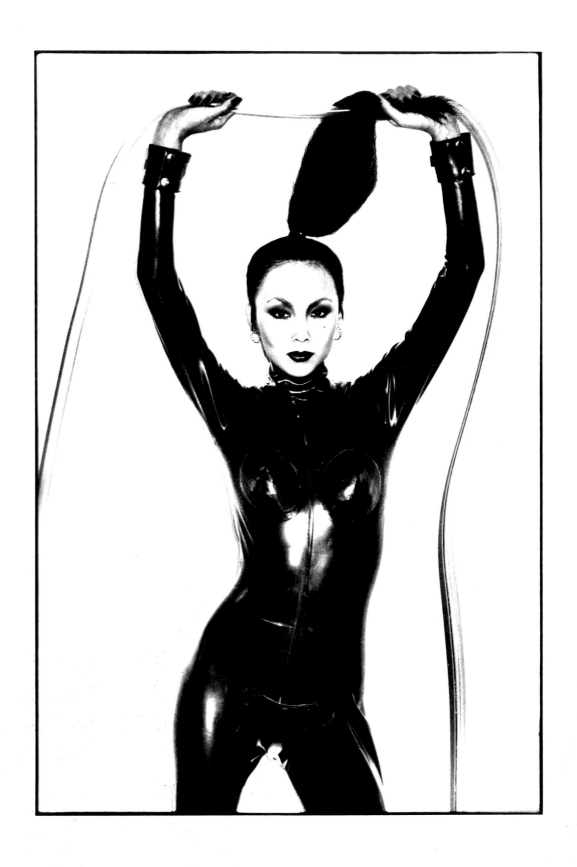

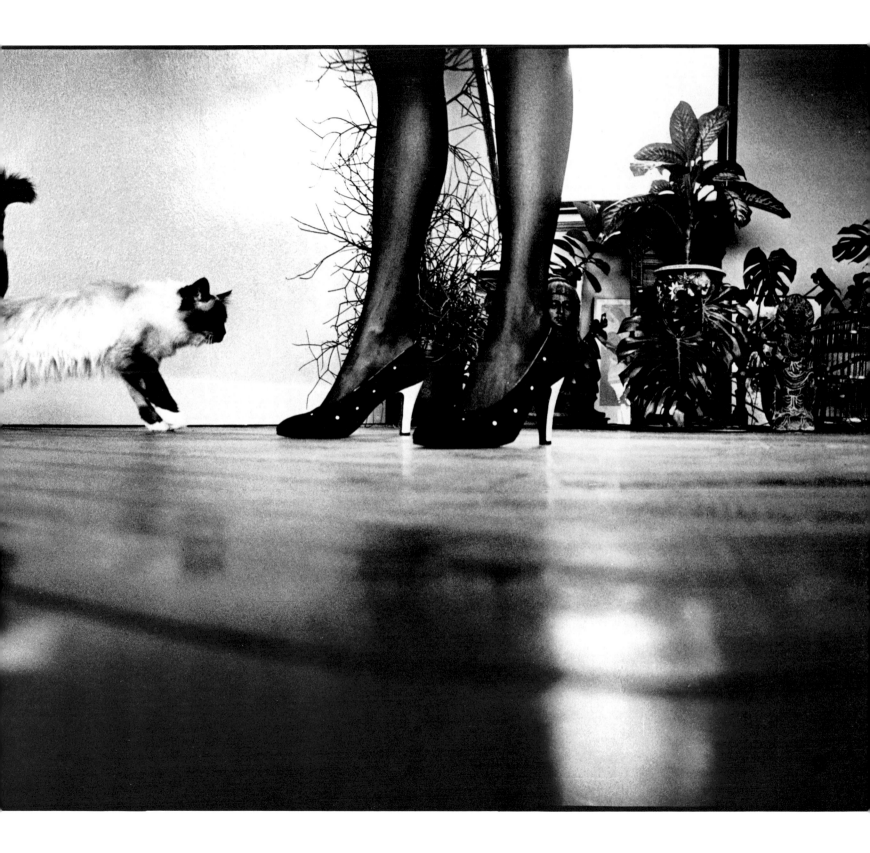

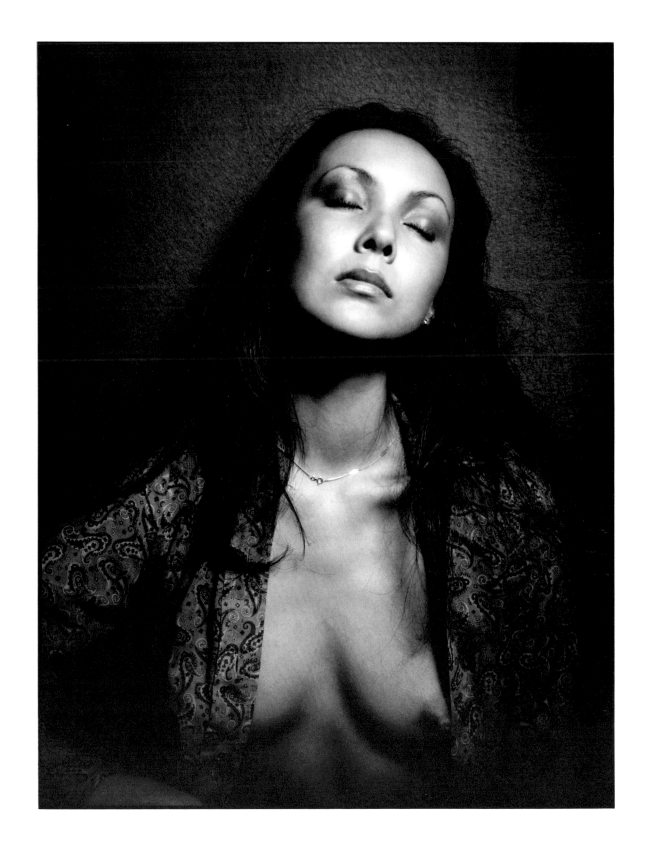

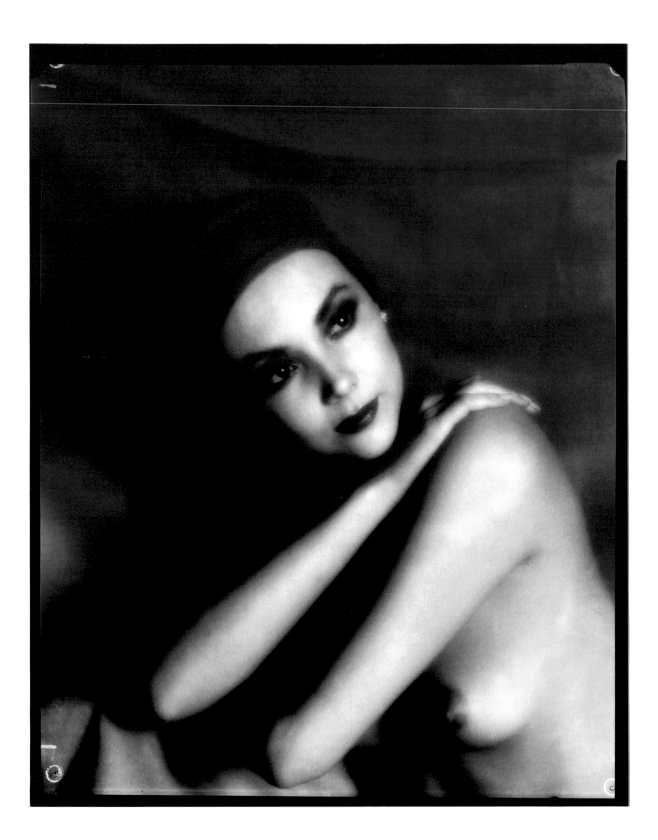

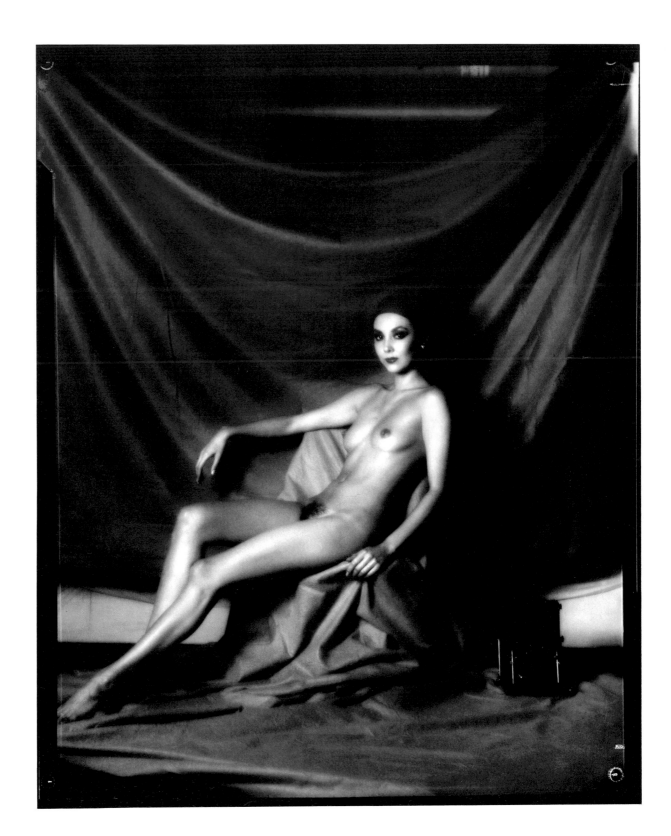

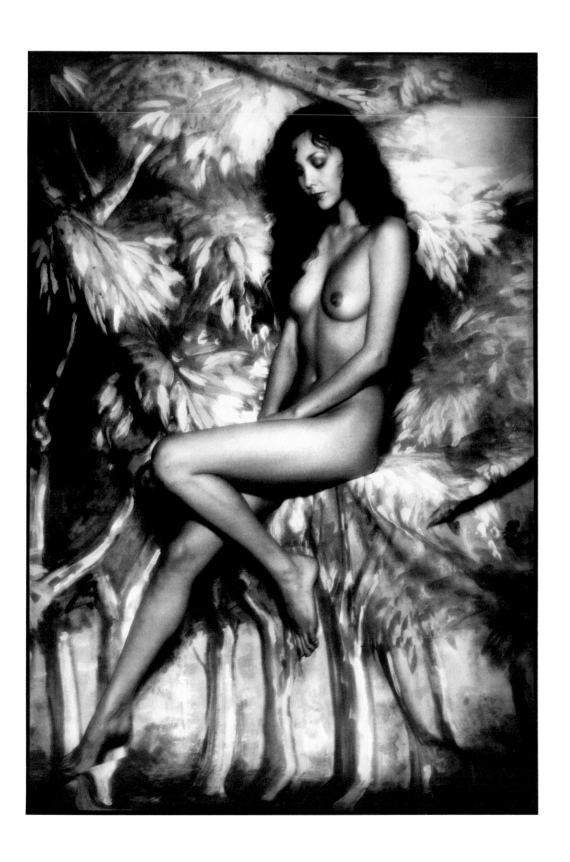

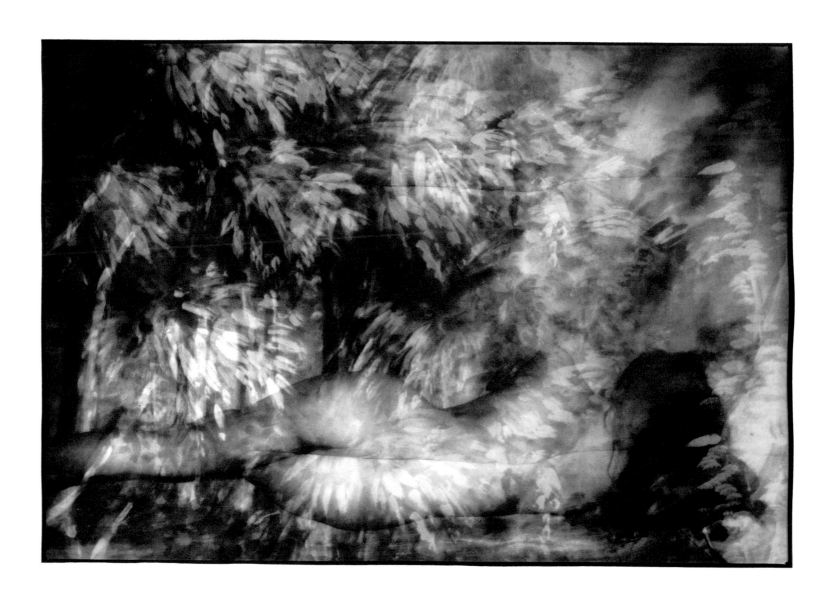

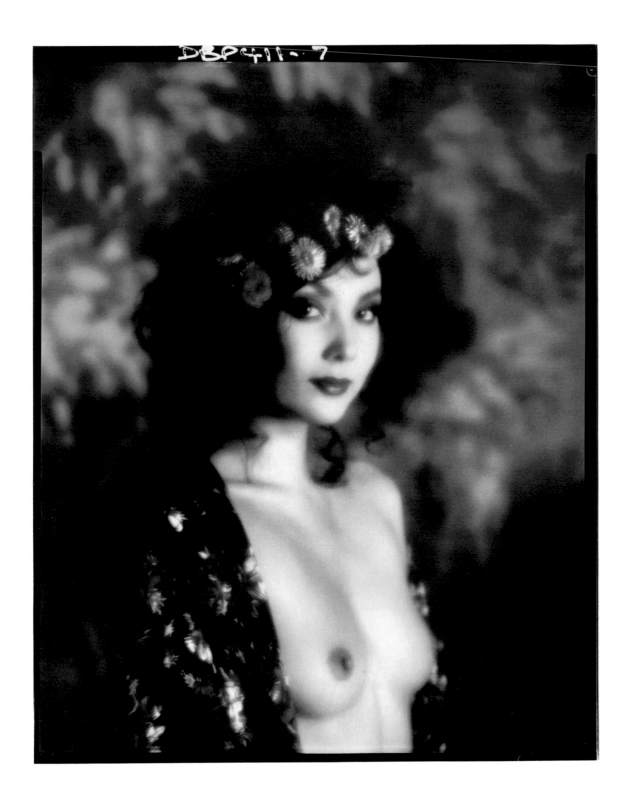

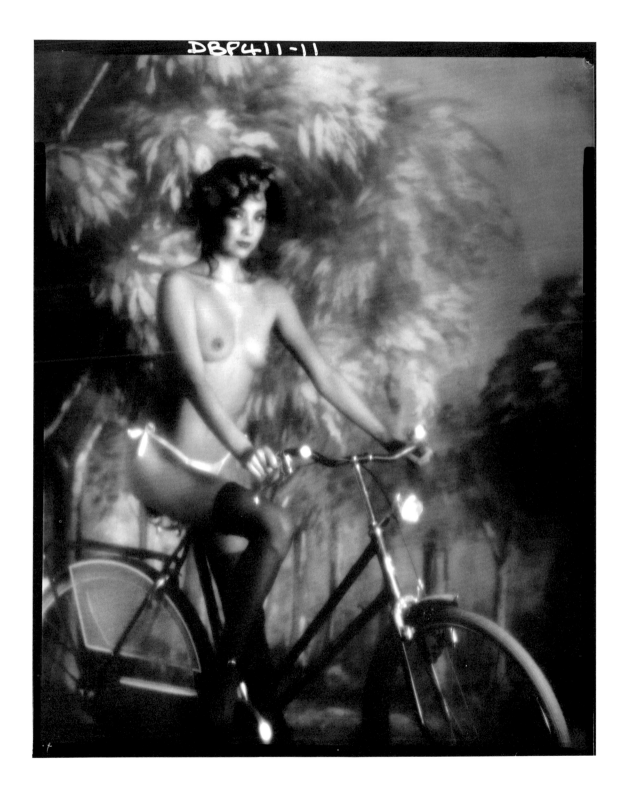

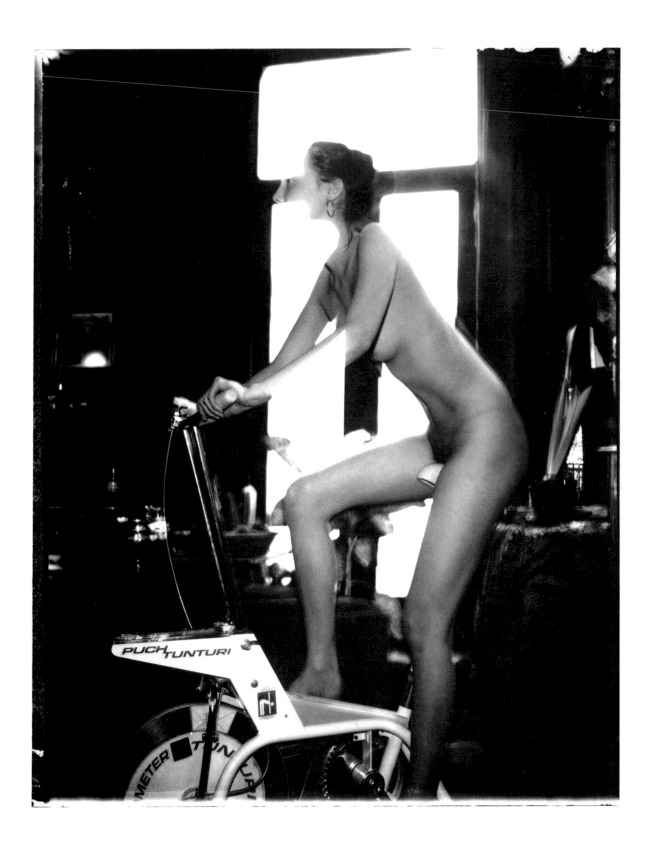

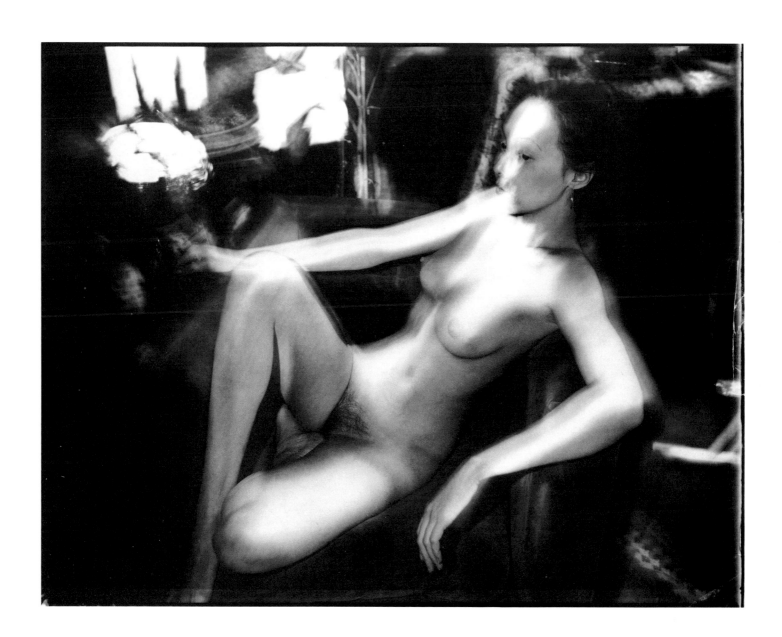

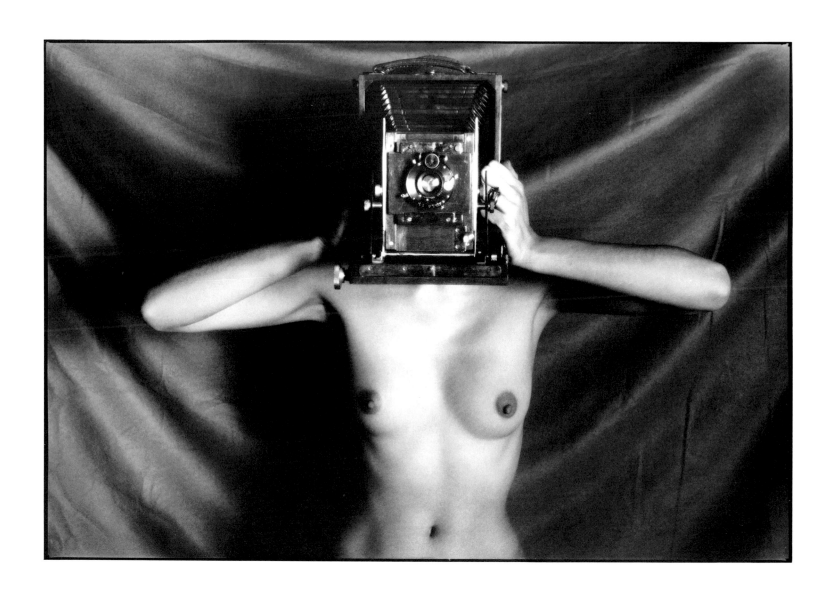

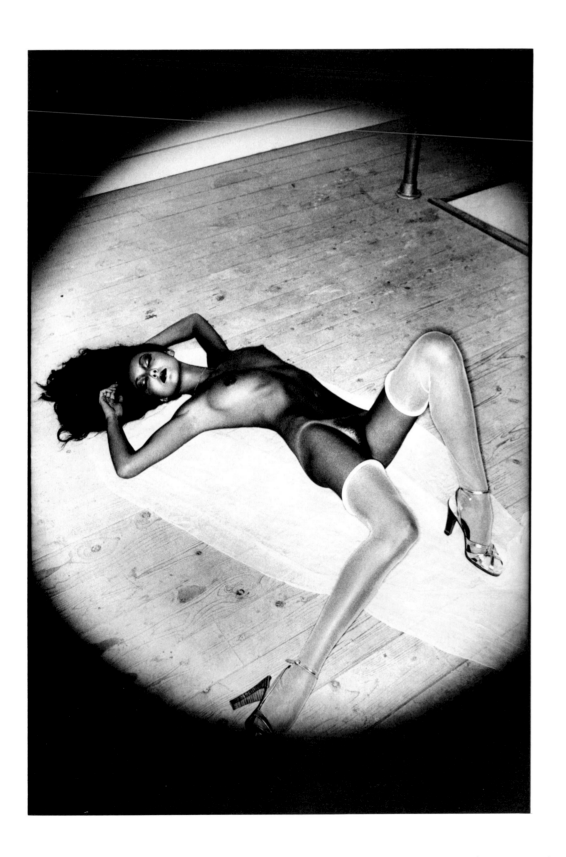

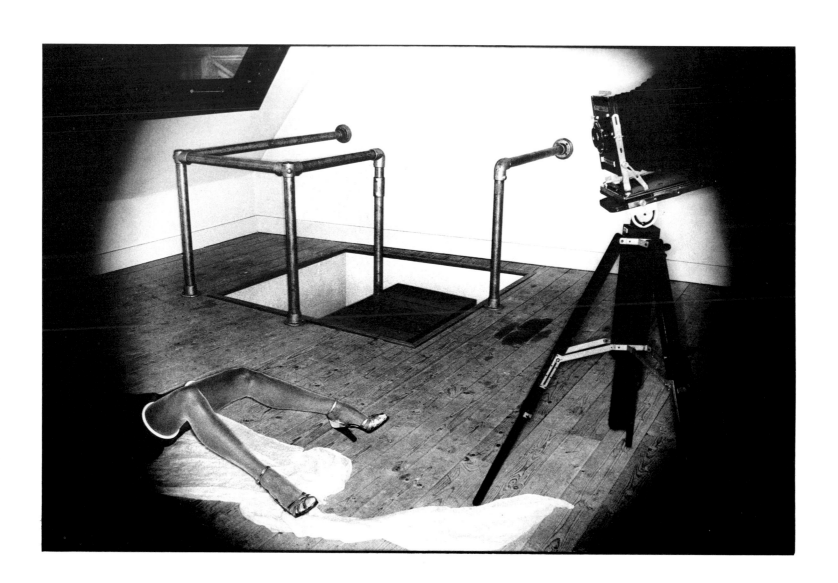

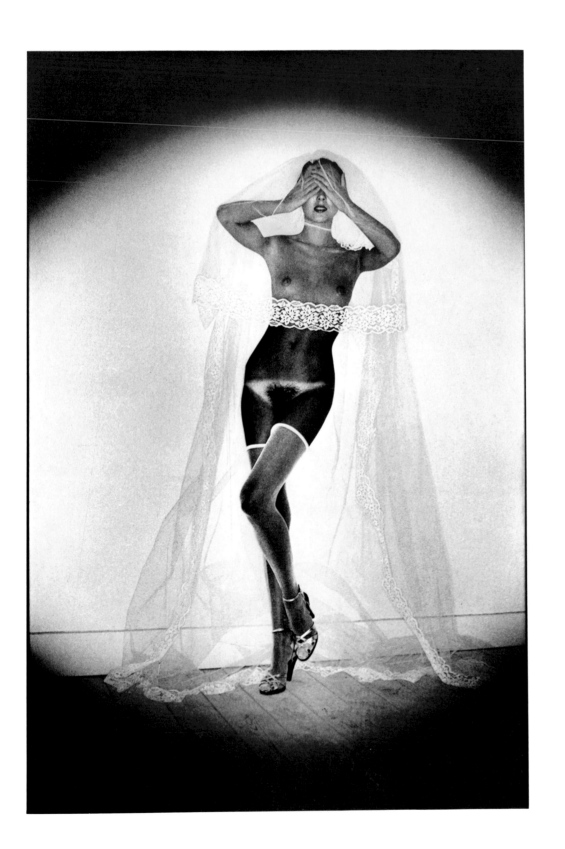

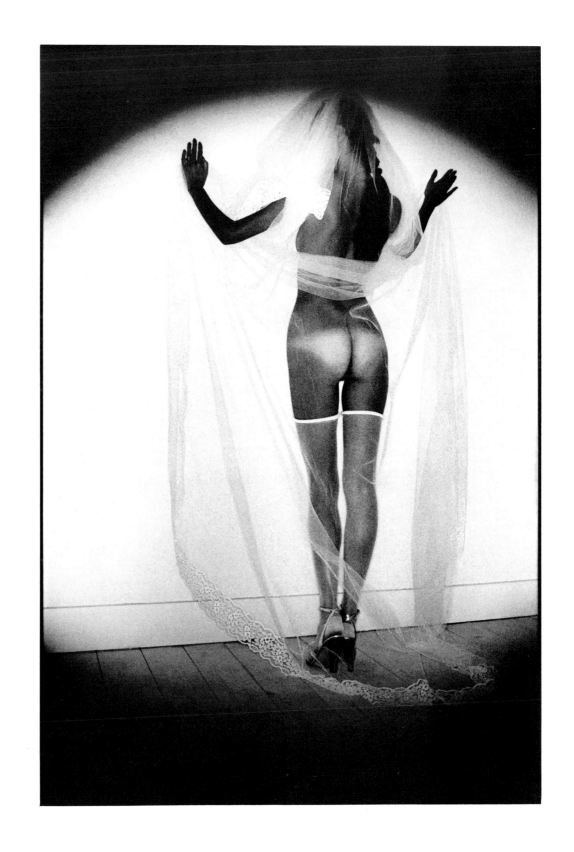

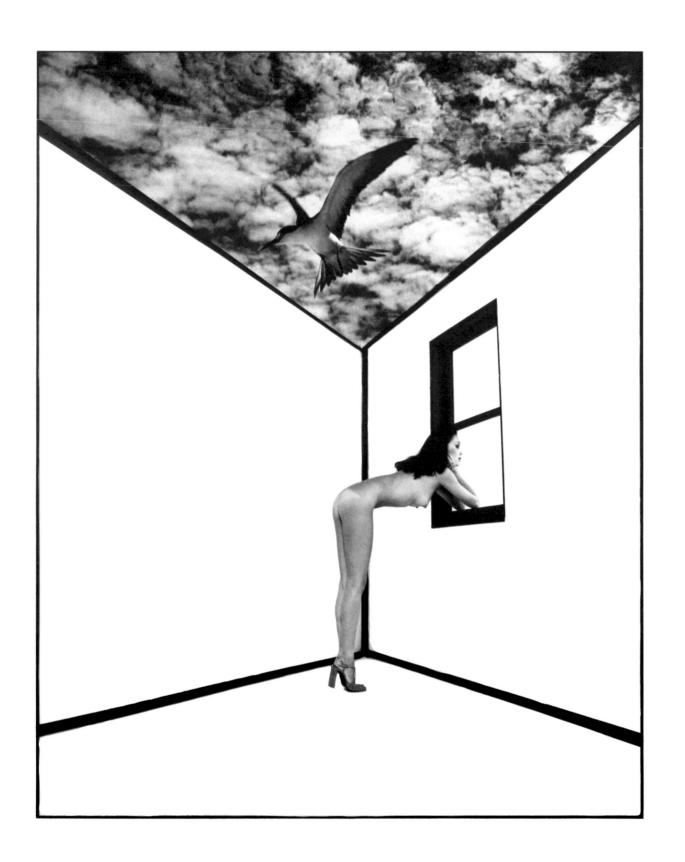

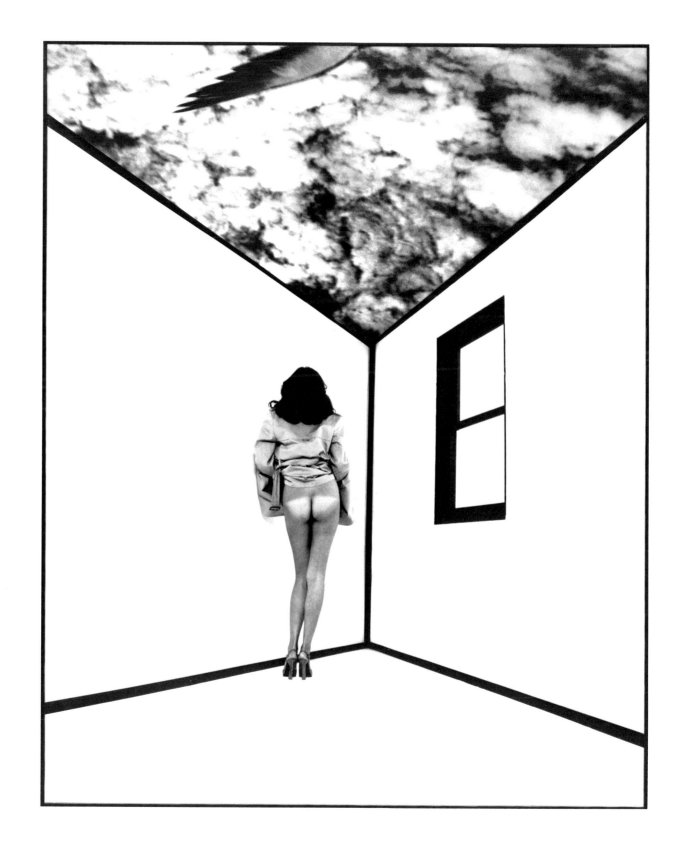

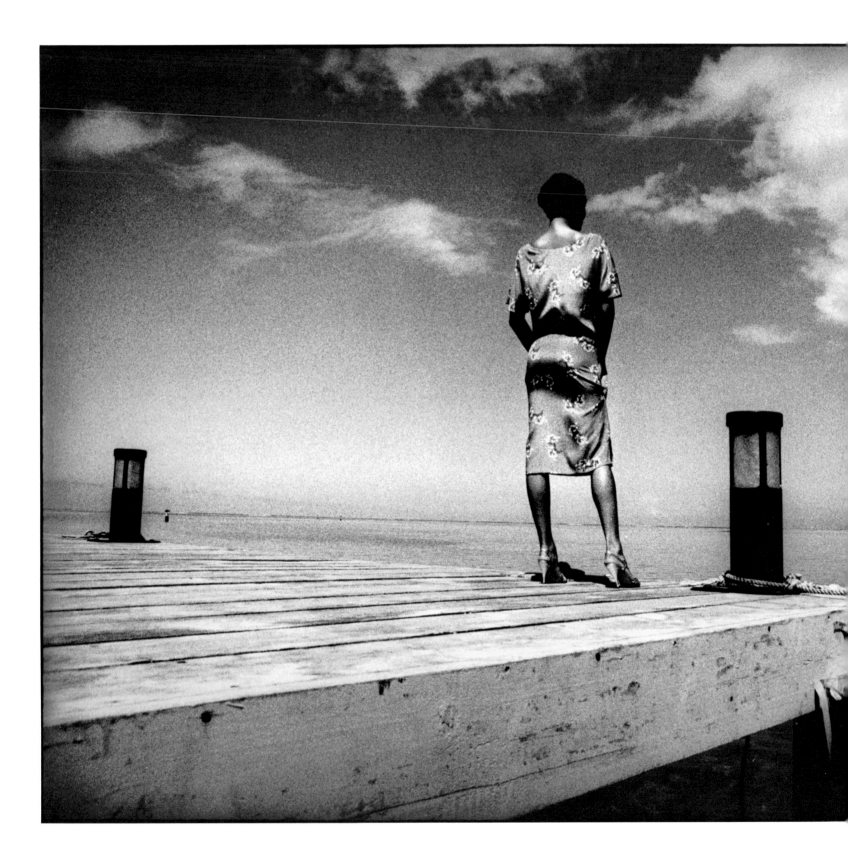

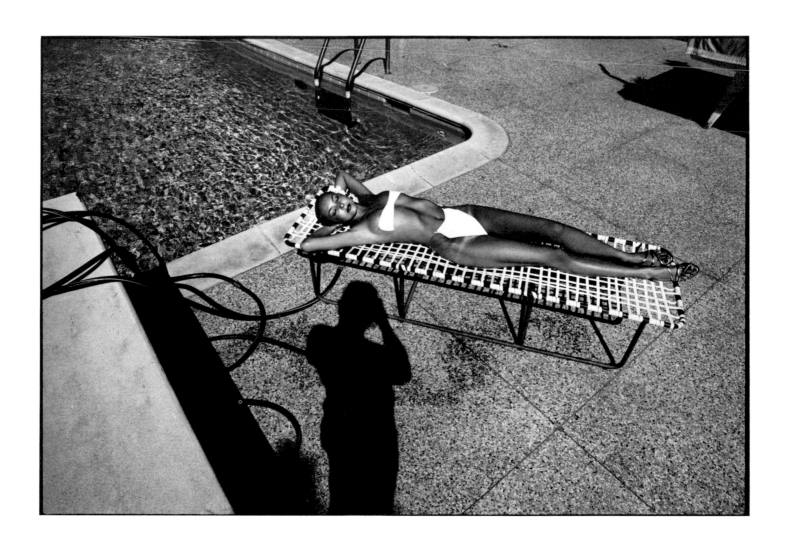

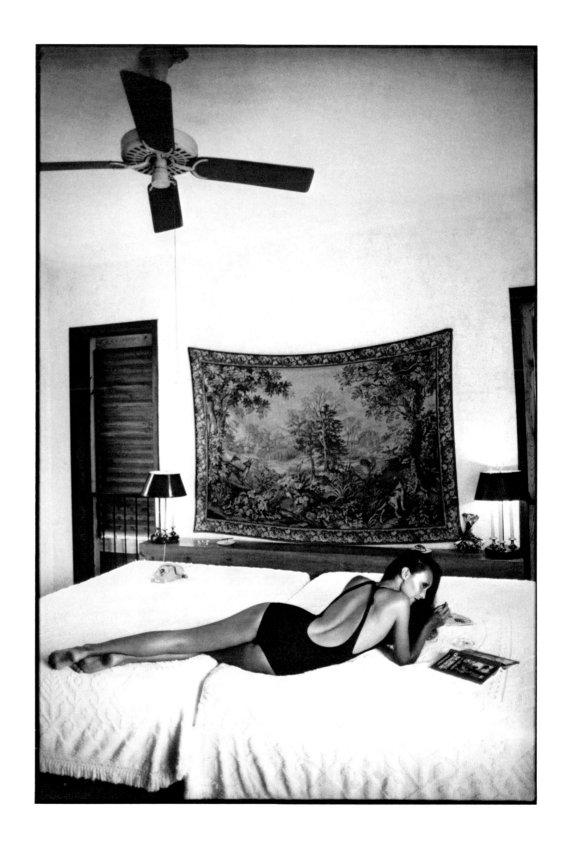

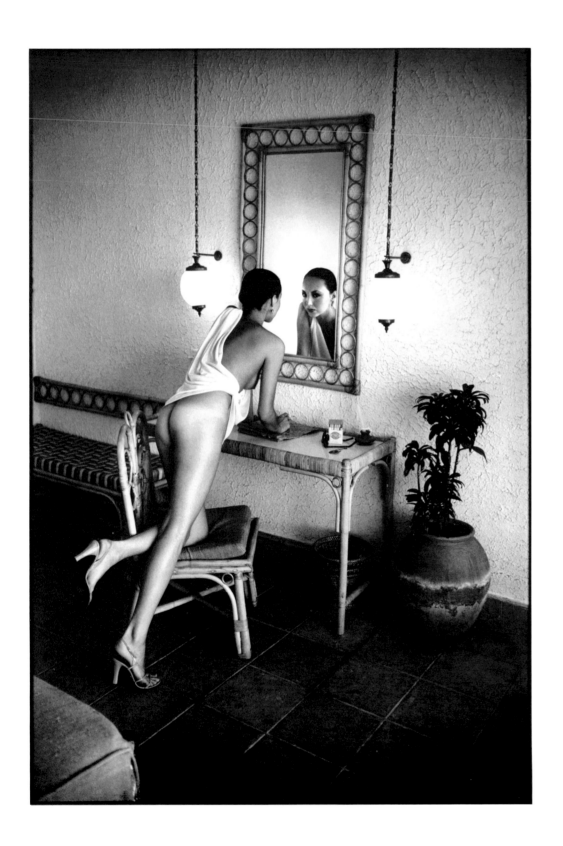

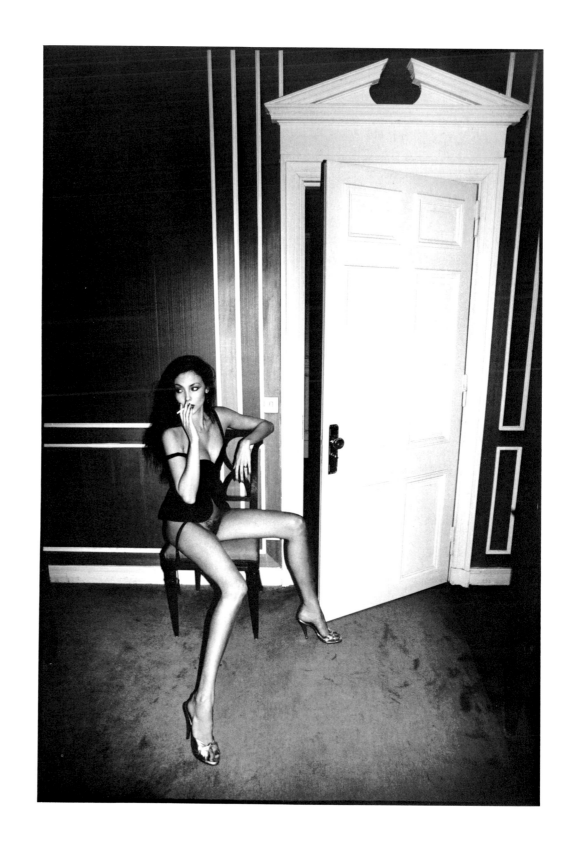

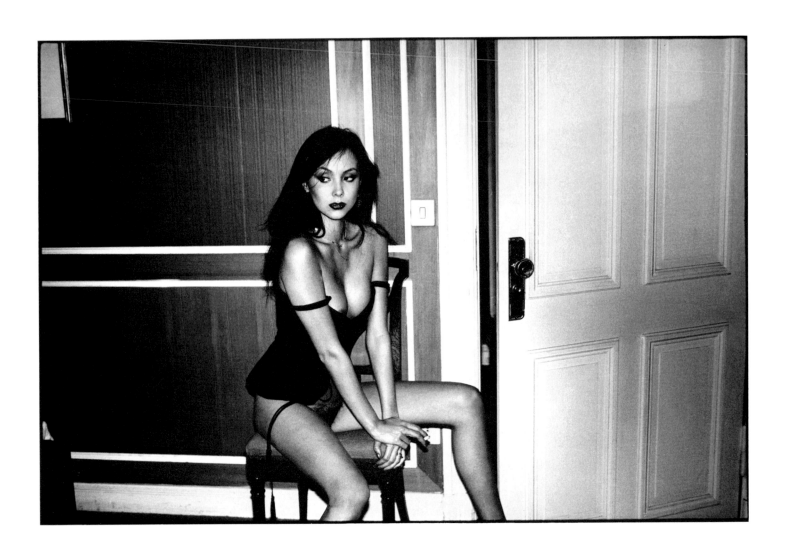

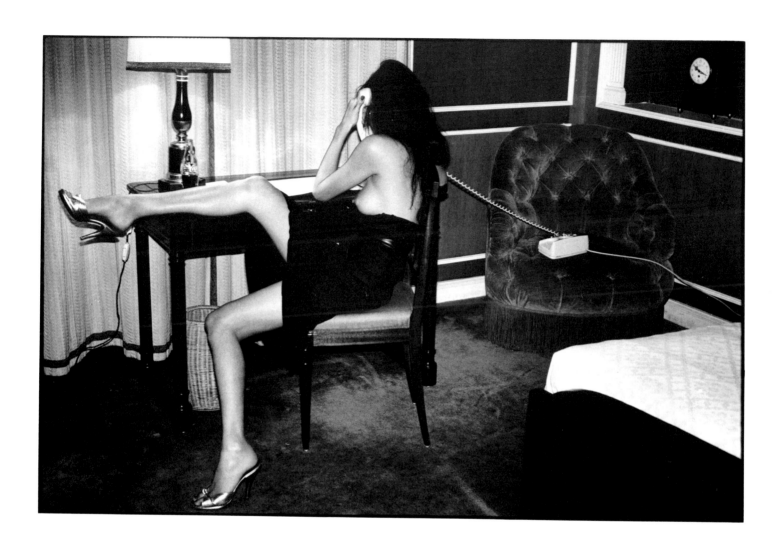

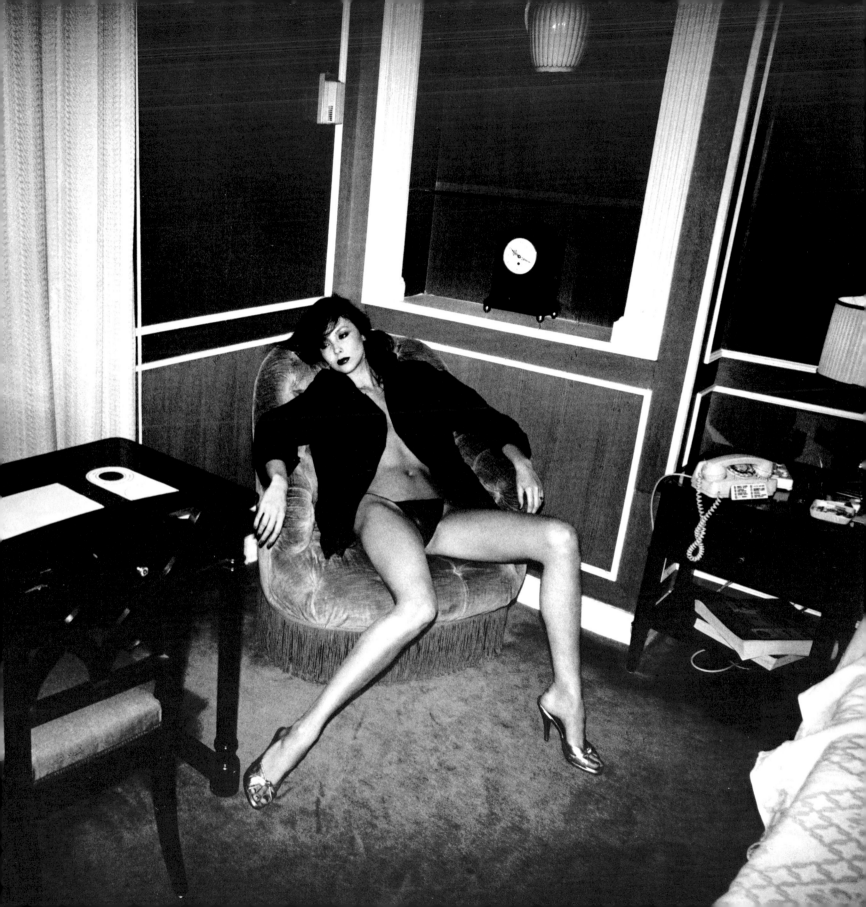

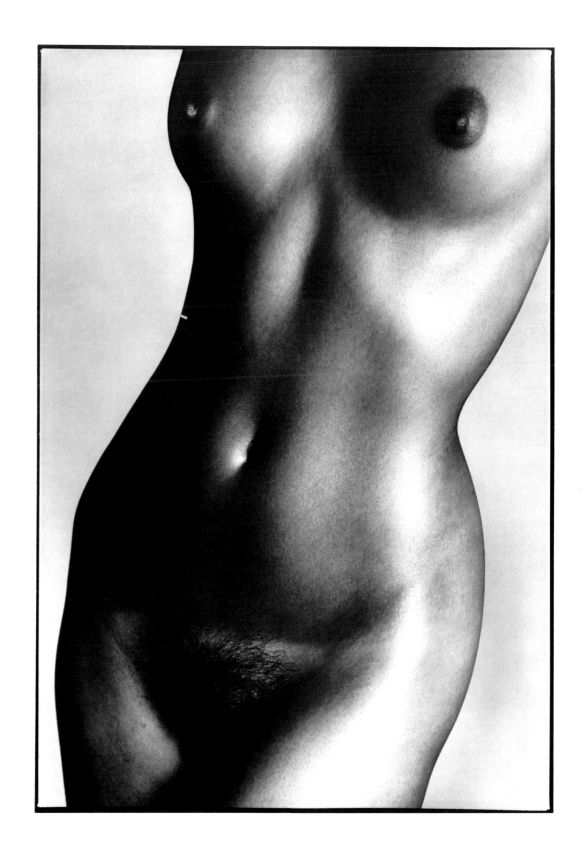

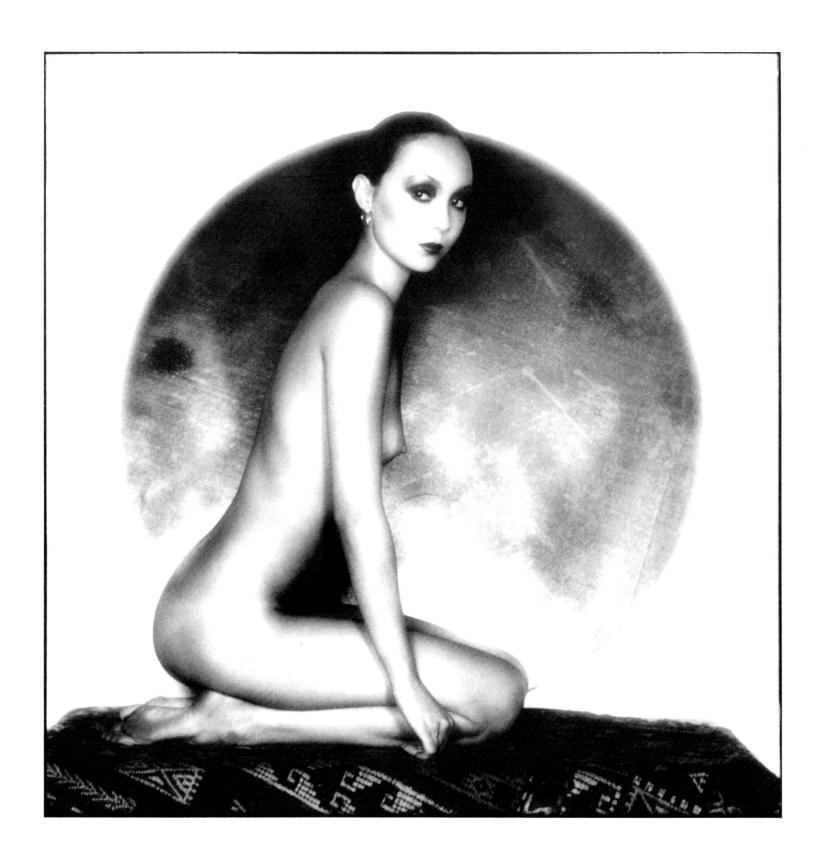

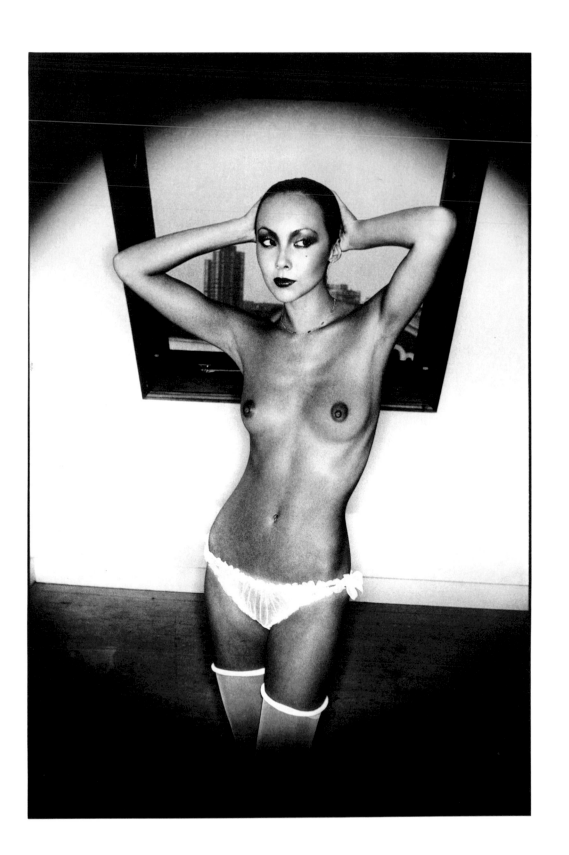

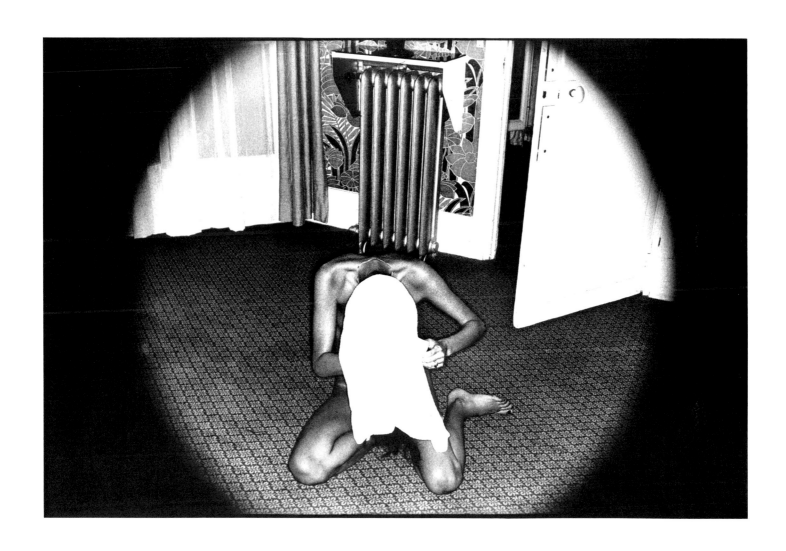

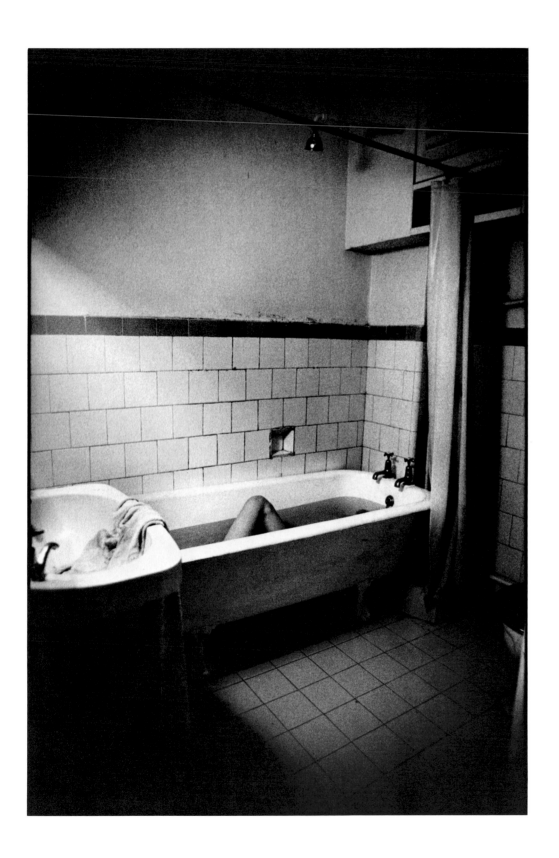

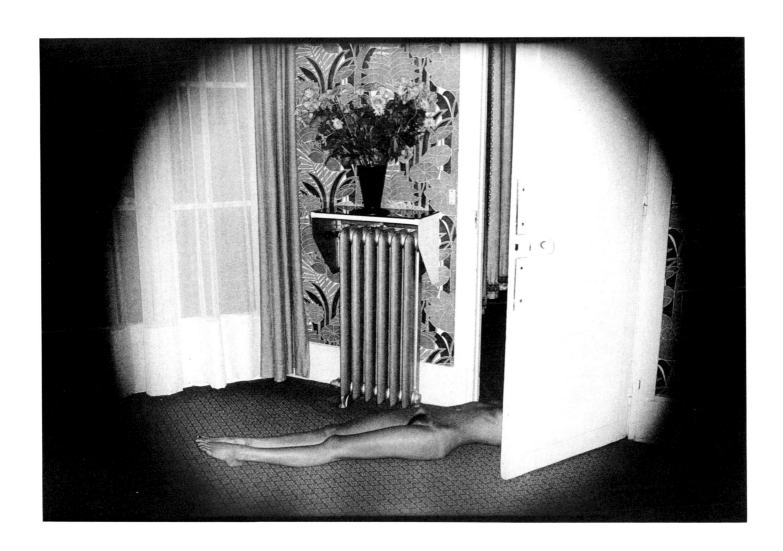

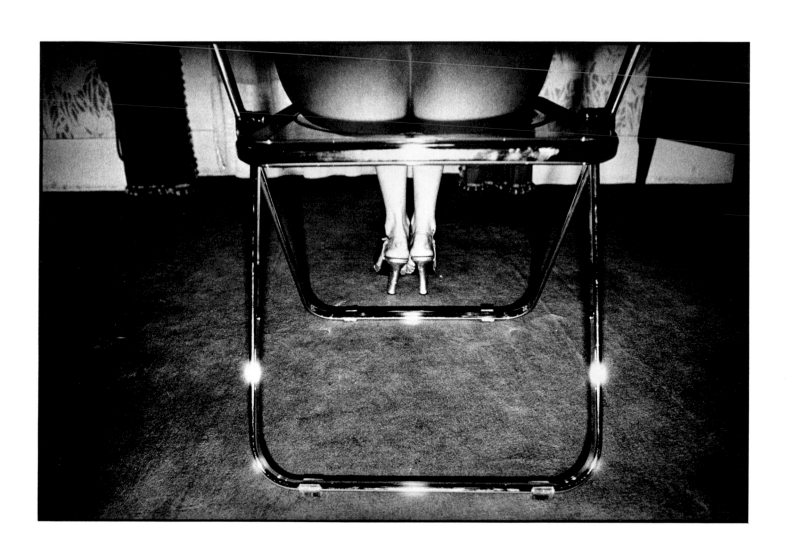

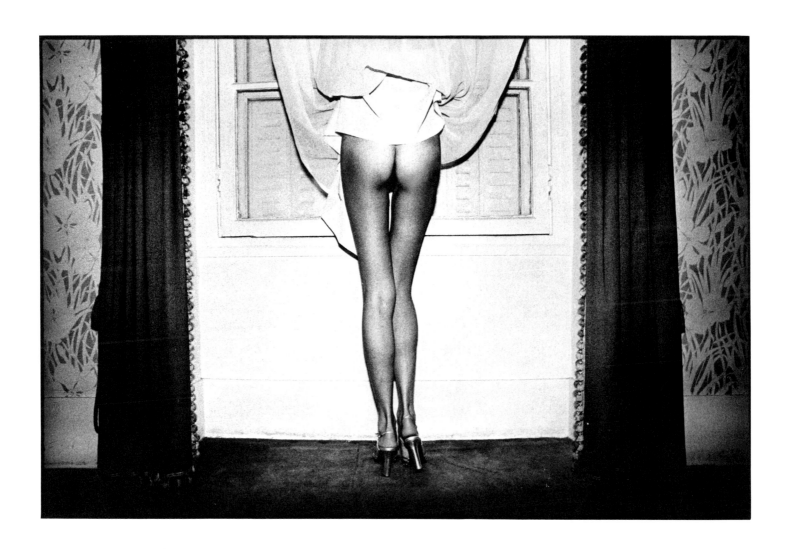

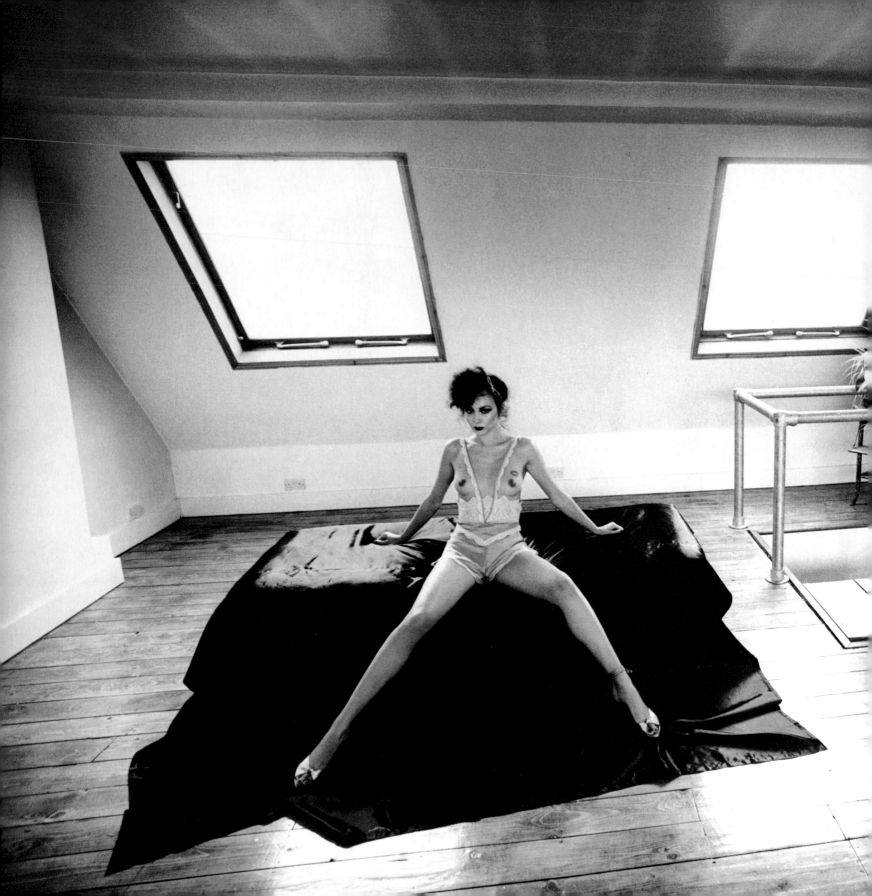

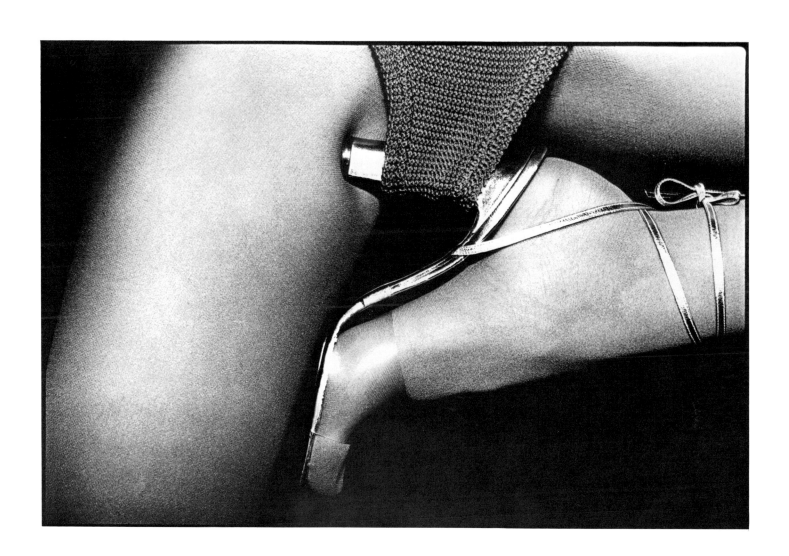

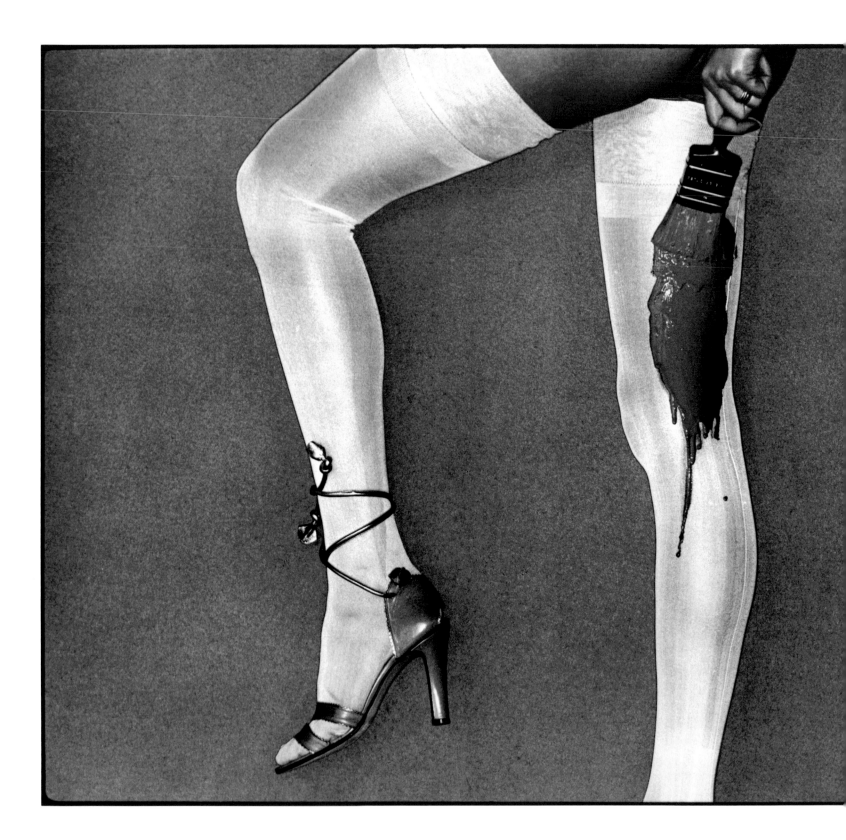

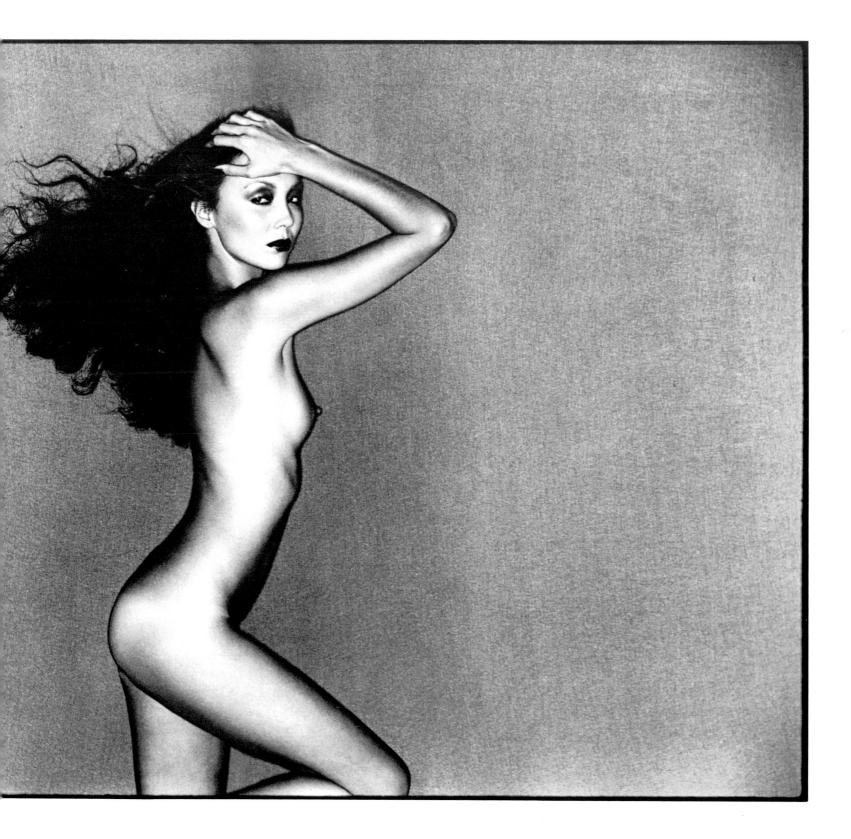

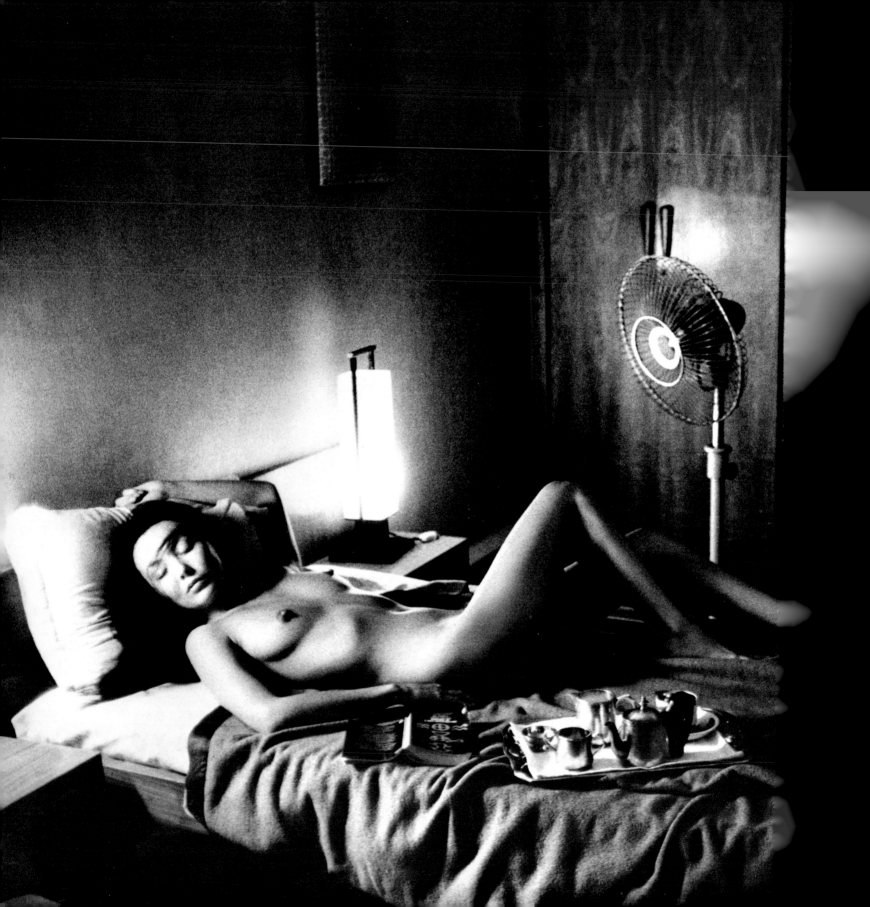

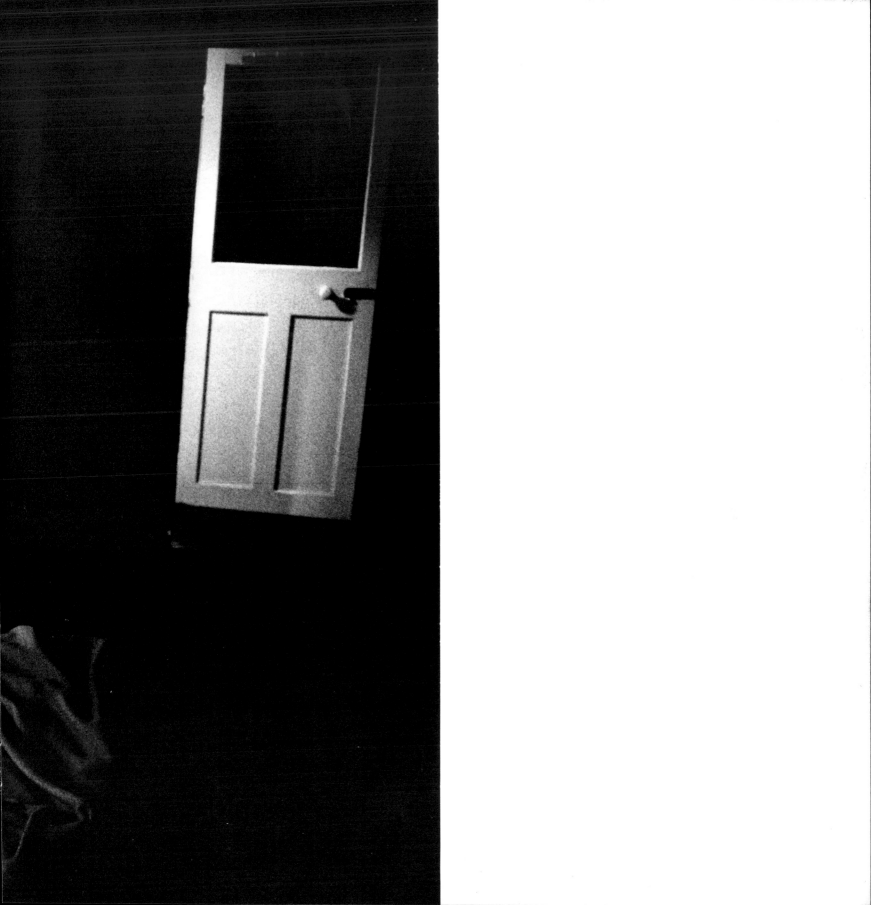

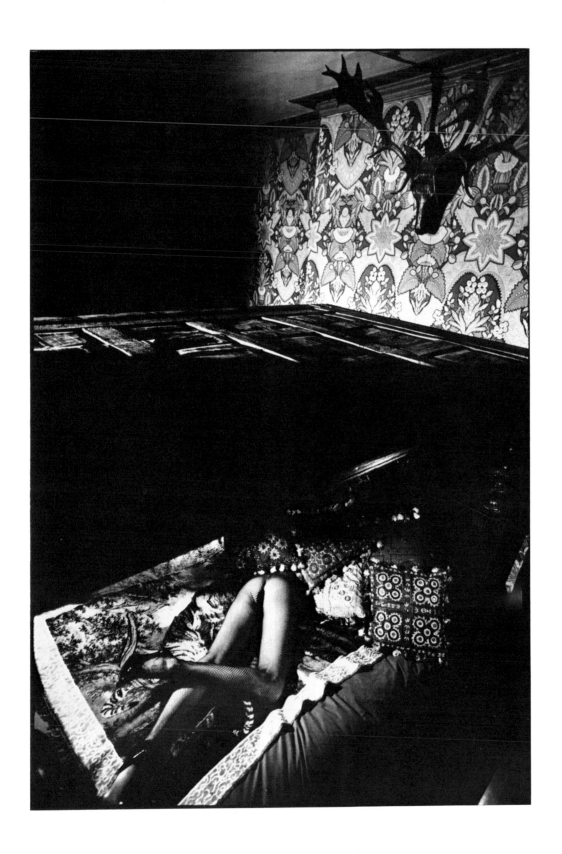

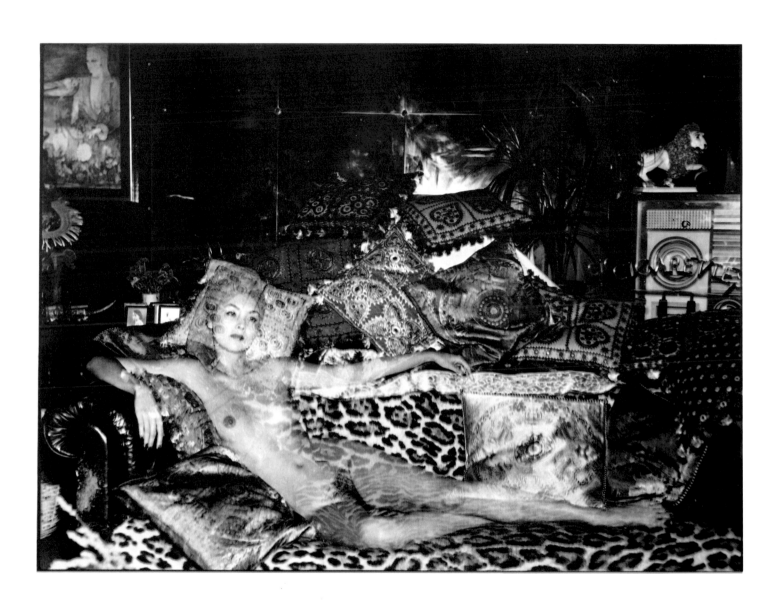

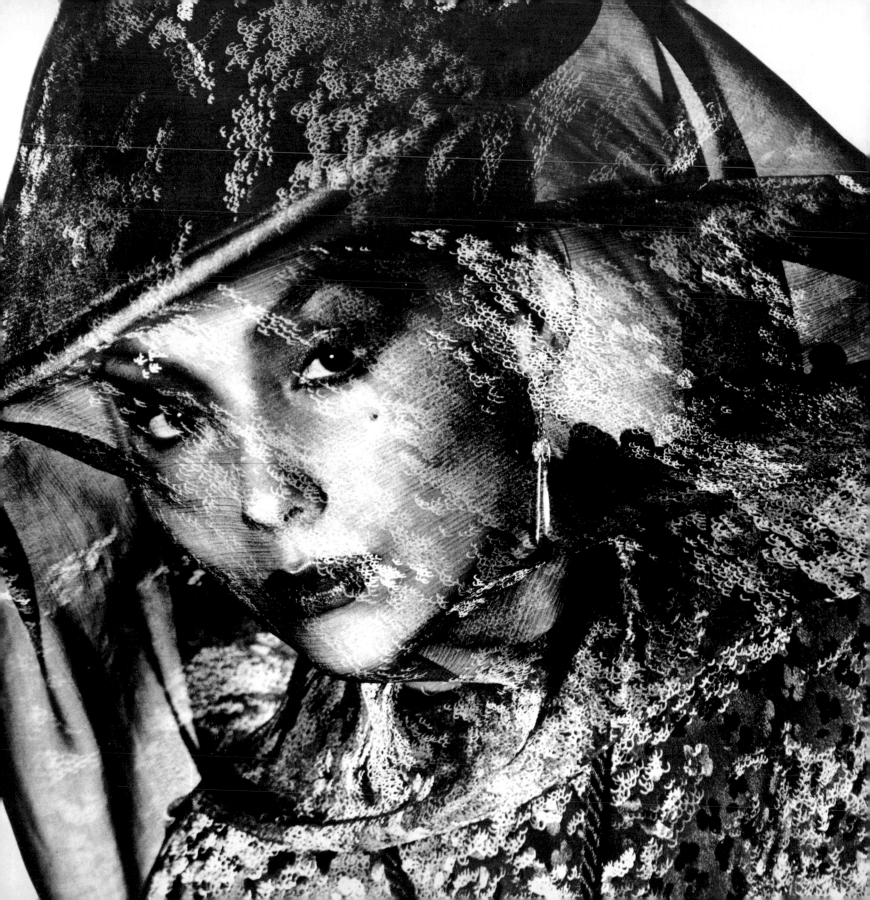

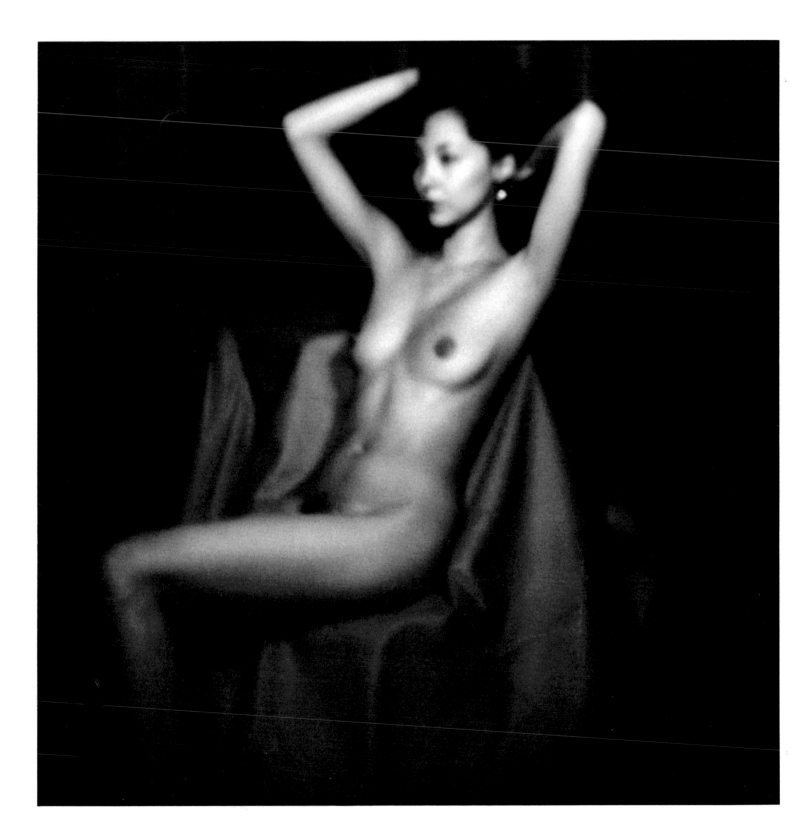

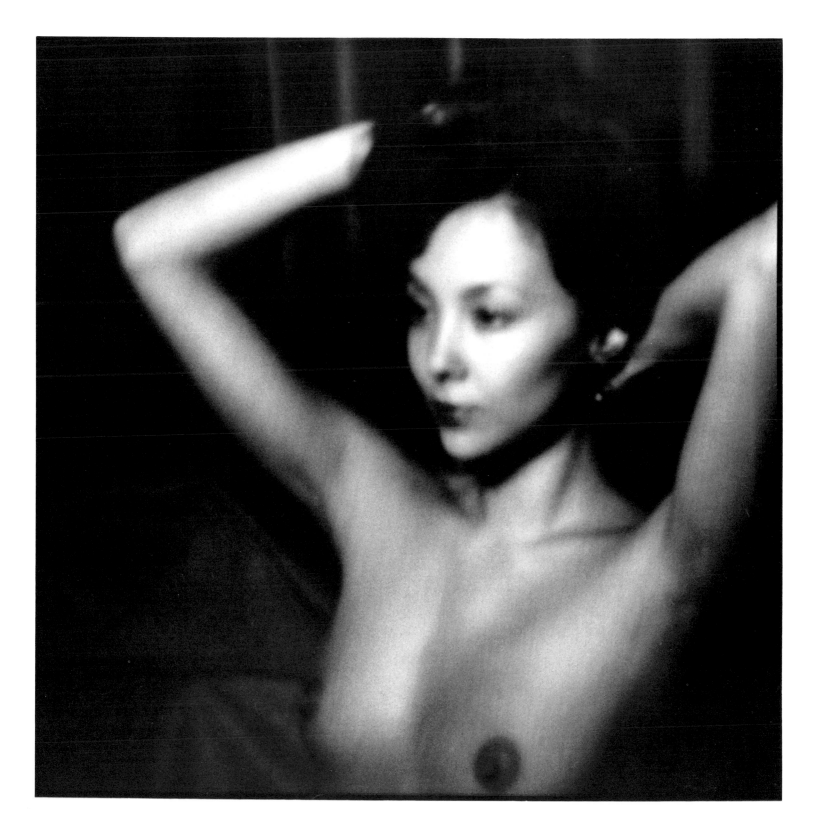

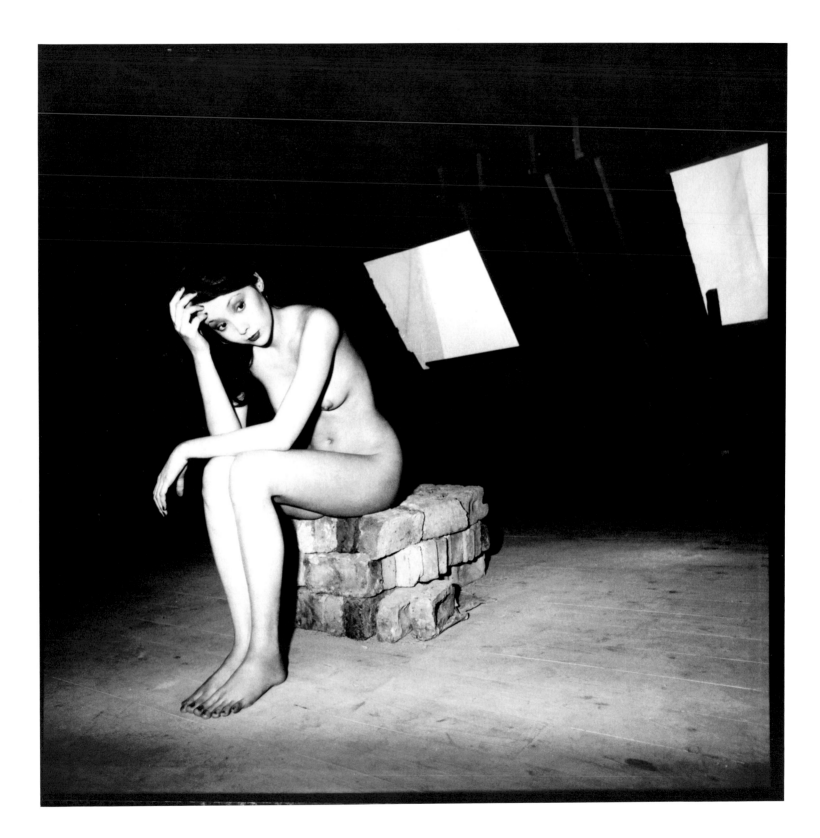

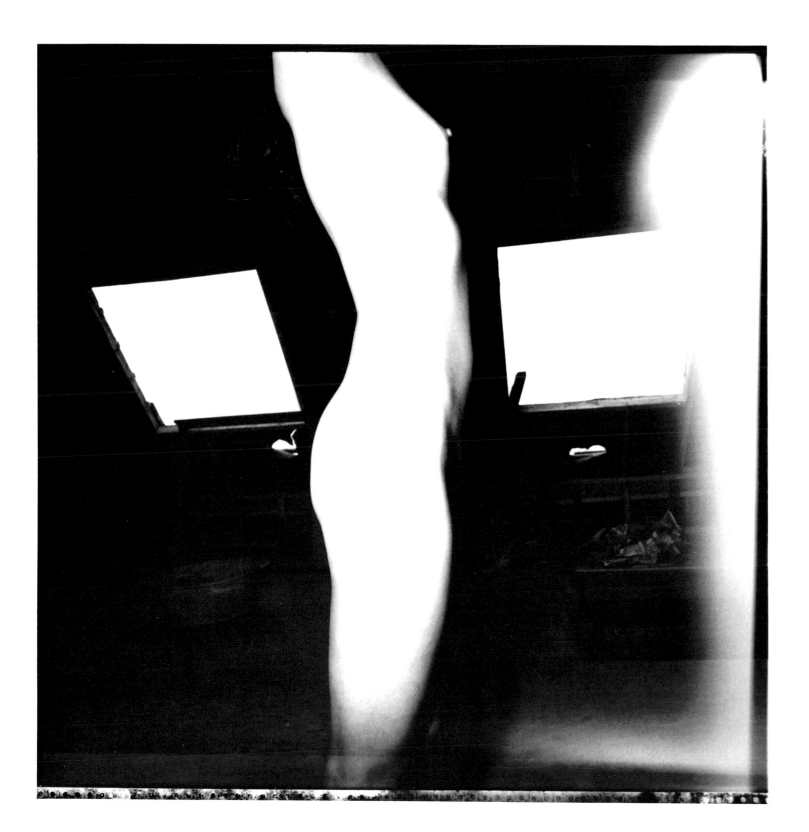

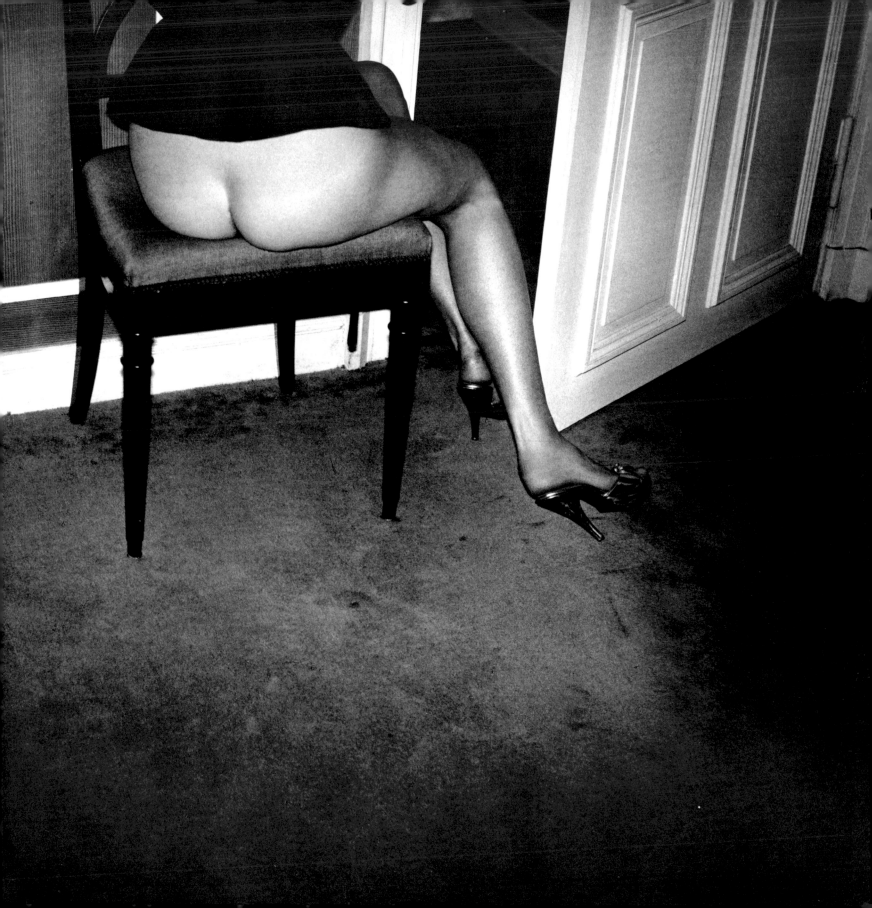

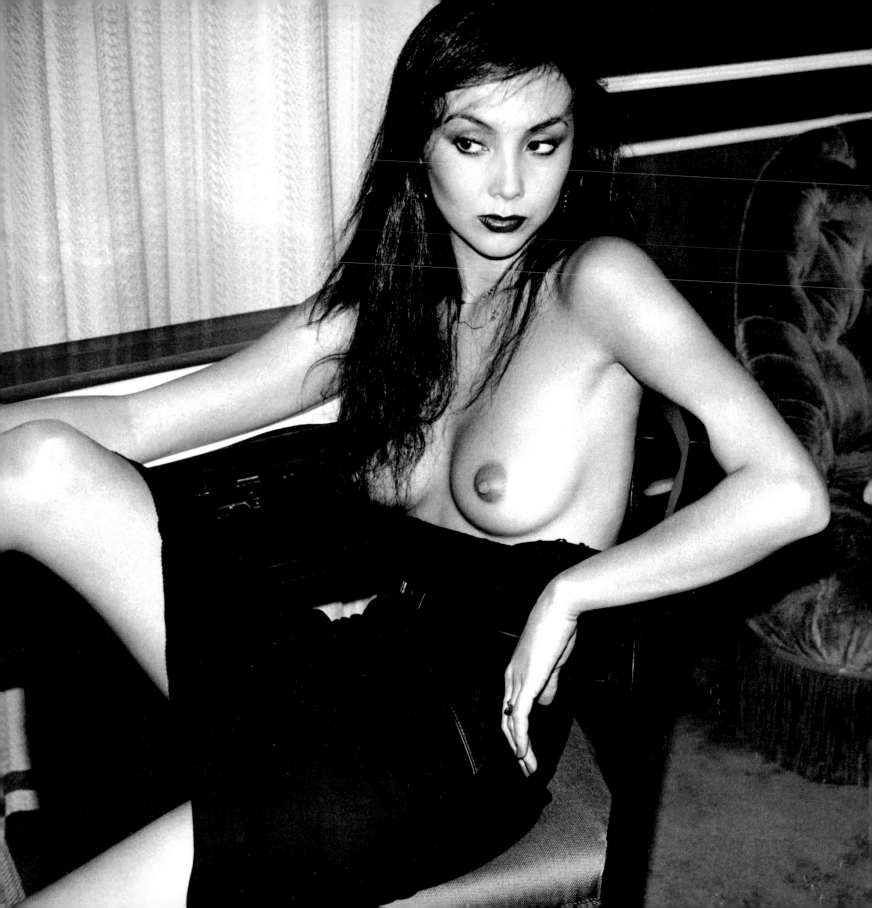

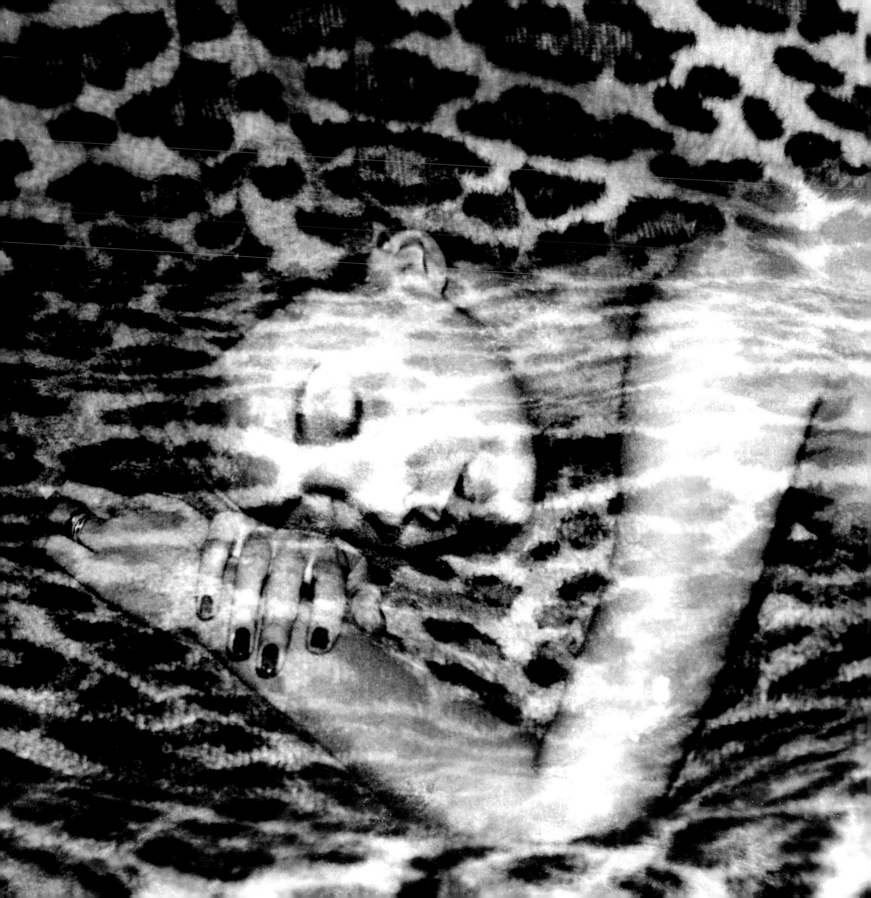